RAPTORS

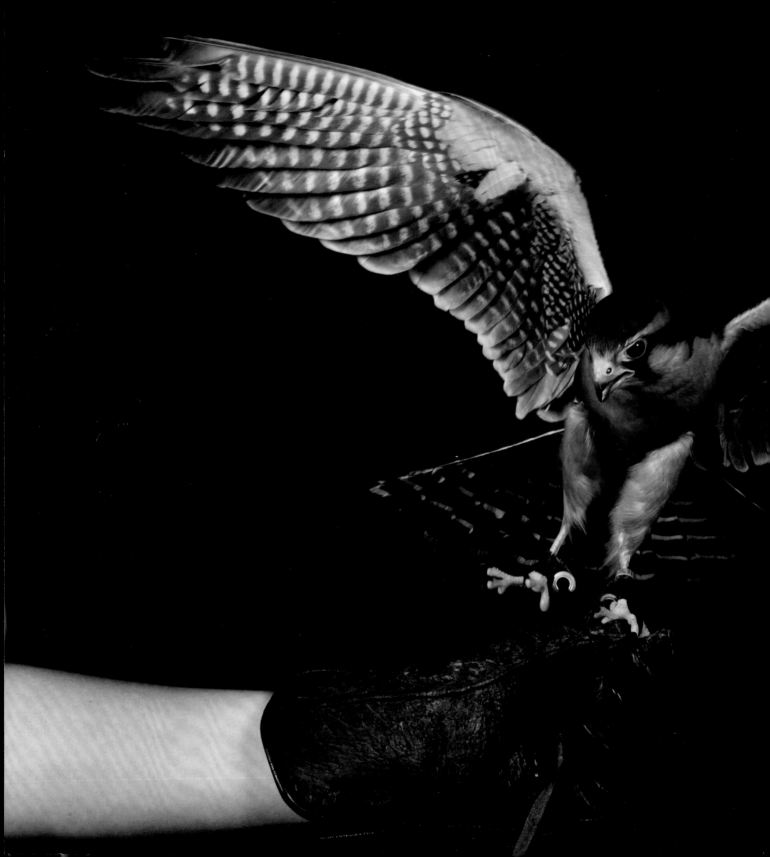

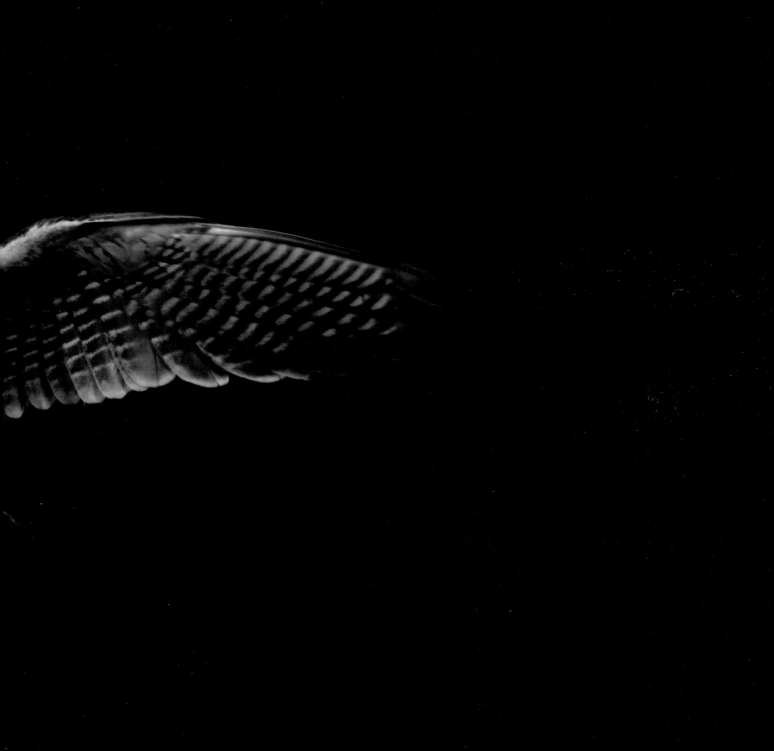

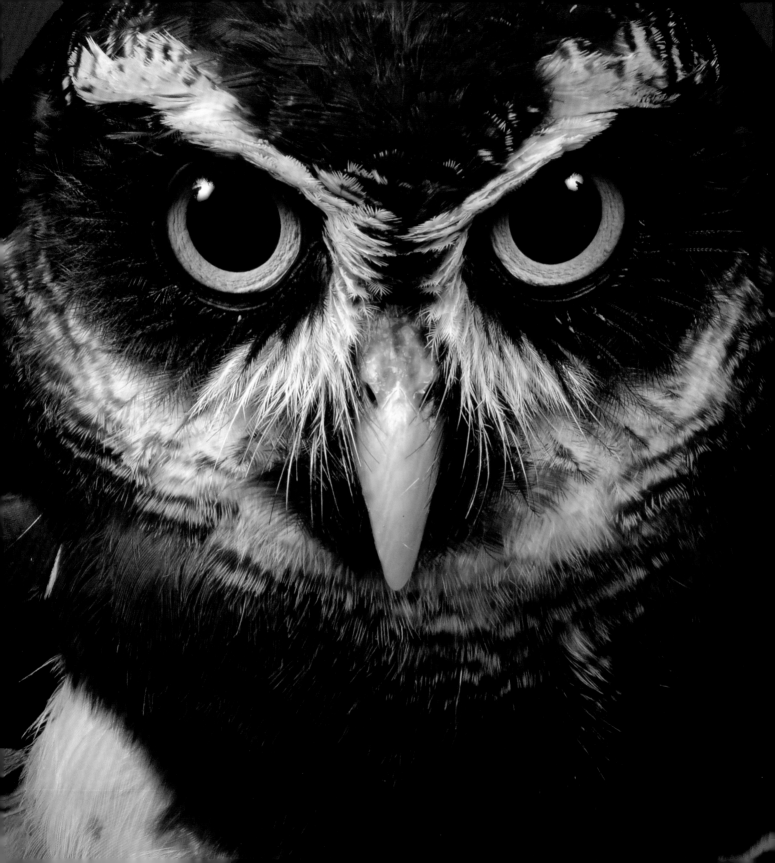

Raptors

Portraits of Birds of Prey

TRAER SCOTT

Princeton Architectural Press
New York

for AGATHA

Published by
Princeton Architectural Press
A McEvoy Group company
37 East 7th Street, New York, NY 10003
202 Warren Street, Hudson, NY 12534
Visit our website at www.papress.com.

Editor: Sara Stemen
Designer: Mia Johnson

Special thanks to: Janet Behning, Nolan Boomer, Nicola Brower,
Abby Bussel, Erin Cain, Tom Cho, Barbara Darko, Benjamin English,
Jenny Florence, Jan Cigliano Hartman, Susan Hershberg, Lia Hunt,
Valerie Kamen, Simone Kaplan-Senchak, Jennifer Lippert,
Kristy Maier, Sara McKay, Eliana Miller, Wes Seeley, Rob Shaeffer,
Paul Wagner, and Joseph Weston of Princeton Architectural Press
—Kevin C. Lippert, publisher

Library of Congress Cataloging-in-Publication Data
Name: Scott, Traer.
Title: Raptors : portraits of birds of prey / Traer Scott.
Other titles: Portraits of birds of prey
Description: New York : Princeton Architectural Press, [2017]
Identifiers: LCCN 2016059210 | ISBN 9781616895570
Subjects: LCSH: Birds of prey—Pictorial works. | Photography of birds. |
 Wildlife photography.
Classification: LCC QL677.78 .S36 2017 | DDC 598.9022/2—dc23
LC record available at https://lccn.loc.gov/2016059210

Contents

Introduction

When I was young, one of the four bedrooms in our house was simply known as "the spare room." In this superfluous room, there was an ironing board; a flimsy work desk where my father kept scraps of ivory and etching tools for scrimshaw; random boxes filled with the detritus of family life: books, papers, costumes, and photographs that had no other home; and numerous animal cages. The animals had usually come home with my mother from the museum where she was a volunteer. That small natural-science museum had a lot of dioramas displaying a menagerie of dead things and a live-animal education center where schoolchildren came to see and sometimes touch indigenous reptiles and insects, along with some exotic specimens like hissing cockroaches and pythons. From time to time, people brought the museum injured or orphaned wildlife, and my family functioned as amateur rehabilitators, nursing these animals back to health. This was often done with limited knowledge, usually consisting of facts and suggestions that the local library and a few native wildlife experts offered up.

Of all of the animals that shared the rather dull, suburban experience of life in the spare room, the one that I remember the most was a tiny screech-owl who lived with us for several months. I believe that this tiny owl had flown into someone's sliding glass door, of which there were a great many in North Carolina. The panoramic reflections in these giant sheets of glass (like those in any window) confuse birds and cause many millions of avian deaths every year.

This owl had been stunned and suffered an injured wing. Only about seven inches tall, the little owl that we categorically named "Screech" lived in a small wire cage in the spare room, where she perched and slept and clicked her beak when she wanted something. We fed her live, unconscious mice, which she swallowed whole, usually pausing with the poor creature's tail hanging out of the side of her mouth like a postmeal cigarette. Her beautiful feathered eyelids silently opened and closed over huge, unmoving eyeballs while her head swiveled impossibly far around her tiny neck.

I remember being struck by how something so small could be so powerful. Her downy feet were disproportionately huge, with talons that looked as if they had been filed to razor-sharp points. They gripped the perch with primordial authority and seemed to belong to a much larger, more dangerous animal. There was something almost prehistoric about her: a quiet but majestic might that our domestic pets lacked.

As an animal photographer, I have since discovered that this intensity is present in many forms of wildlife. I think it is what fascinates us about wild animals—this feral wisdom and extreme ability that are encoded in them. It is a body of knowledge that perhaps, as a species, we once possessed but now can only admire in other animals.

Whether it is due to intelligence or specific adaptations, some species simply have a greater presence than others. Raptors are without fail among the most enigmatic and powerful creatures in the animal kingdom. They are uniquely graceful and intelligent, fluid and fierce. They deserve our fascination, respect, and reverence.

A raptor is a bird of prey, an avian species that is predatory. The term raptor comes from the Latin word *rapere*, meaning to snatch, grab, or take away. Although many species of birds hunt and eat meat, there are a few physical characteristics that set raptors apart. All raptors share a keen sense of sight, sharp talons, and a hooked beak. Eagles, owls, hawks, vultures, kites, and ospreys are all considered to be raptors.

I started this project in 2011, when I was pregnant with my daughter. I don't remember how the idea came to me, but my first trip took me to the Vermont Institute of Natural Science in Quechee, Vermont. This was several years before I took the photos in my book *Nocturne: Creatures of the Night*, and at that point I had never photographed anything but dogs in a studio setting. I spent two days there photographing about a dozen of their birds on a black fabric backdrop draped over a folding table and lit with two flash heads.

The birds, all unreleasable wildlife who had become education animals, were very used to being handled but were not accustomed to standing on a table. Something that I had not entirely considered is that most birds of prey rarely walk or even stand—they almost always perch. Their feet and long talons are made for gripping, tearing, and piercing, not standing. But in order to photograph their entire bodies on a backdrop, I needed them to stand. Some took to it easier than others. Some gaped at the table, staring at their feet almost as if they had never noticed them before. Usually once the handler gave them a mouse or two, they eased up and I was able to get some shots. Some of the birds enjoyed the table and would hop around on it. Some just tried to fly away. Years later my husband and I developed a special perch that was painted black, which we could unscrew, break down, and carry on a plane, but for the time being, I had learned a lot about raptors.

I produced a sample portfolio, but I wasn't able to find a publisher for the collection at that time. Instead I ended up doing a sweet, maternal book about newborn puppies, which coincided with the birth of my daughter. When I began working on my nocturnal animals project in 2013, I revisited the raptor photos and ended up using some of the owl images in *Nocturne*. Eventually, three books later, we decided to try *Raptors* again, and this time it took.

On an almost daily basis, someone asks me what my next project will be. There is always a next project. Depending on what it is and where I am at the time of the

question, I feel compelled to offer an explanation. With this project, I just said: "Raptors. My next project is about raptors." Although this word, I determined over time, makes many women wince. It seems to be a very masculine word, associated with everything that femininity typically is not: ferocity, brute strength, and predation.

I somehow think that Helen Macdonald's brilliant book might have sold fewer copies had it been titled *R Is for Raptor*. In the commercial world, it is macho, tough things that are given the name raptor: off-road trucks, male athletics teams, gun mounts, loud power tools, even an herbicide for conventionally grown soybeans. These are things that are fierce, manly, indestructible, deadly. But surprisingly, almost all of the people I met in the making of this book were, in fact, women.

Horizon Wings is a predominantly female-run wildlife rehabilitation center in Ashford, Connecticut. The property is open to the public only by permission, and Horizon Wings funds its work entirely through donations and educational presentations. The center has more than fifteen resident birds, who live in a tranquil, wooded lot turned into a raptor community.

My most memorable experiences at Horizon Wings were with the eagles. If you have never tried to hold a golden eagle on a falconer's glove for a prolonged period (and who has?), then I suggest you take a ten-pound dumbbell, grasp it, stick your arm straight out at a ninety-degree angle, and try holding it there. Then pretend that the weight you hold is restless, flapping its seven-foot-wide wings in your face, screeching at you, and digging three-inch-long talons into your glove. There—now you are channeling the experience of the very devoted volunteer who assisted me.

More eagles awaited me at Carolina Raptor Center. CRC is an amazing facility nestled in the woods outside of Charlotte, North Carolina. The center is bustling with activity year-round, as the organization's science education programs serve more than twenty-seven thousand students a year in schools. Their onsite Raptor Medical Center treats nine hundred to a thousand birds a year, releasing almost 70 percent back into the wild. More than thirty-five thousand visitors come to walk the trails and meet the resident birds, who will live out their lives in the sanctuary.

My first visit to CRC was a formal affair with a full studio set up in a (mercifully air-conditioned) classroom and a constant stream of birds brought in all day by staffers and interns. None of the raptor organizations I had previously worked with had such a diverse range of species. Almost all were glove trained and were very used to people, so photographing them was a breeze. There were a few birds, though—like the vultures—who couldn't be brought into the classrooms because their size and temperament made glove training impractical, and so we trekked out into the woods to photograph them.

One at a time, each vulture was let out of its enclosure, and we would try to cajole it onto the background we had set up. But the birds kept stopping in front of the cords for the lights and refusing to step over them. They looked terrified. We tried moving the cords or covering them up, but they still knew they were there.

The staff believed that the vultures may have thought the cords were snakes! Vultures are extremely intelligent and, perhaps because of that, are more aware and fearful of potential dangers than other birds.

Finally we gave up on the backdrop and just let them follow us around. I had been warned to wear black closed-toe shoes because vultures love to peck at feet. And so they do; everyone with colorful shoes was high-stepping to try and dodge the pecking. Apparently, vultures are very tactile with their mouths. Much like human toddlers (to whom they are often compared in intelligence), they learn by putting things in their mouths, so colorful shoes and shoelaces are irresistible. Vultures are comical creatures with loads of personality—really terribly fun birds. If you can get past the fact that they eat rotting carcasses and have poop-coated legs and feet, they're really quite charming.

So when the folks at CRC contacted me a few weeks later to tell me that they had a baby black vulture, I had to go back. There was no way I could not include this spectacularly fluffy, awkward, alien-looking creature in my book. Because I was on a shoestring budget, I decided to fly there and back in one day. I left at around eight in the morning, flew to Charlotte, photographed the baby, had lunch, flew back, and was home in time for dinner. My daughter didn't even know I was gone on this day that was quick, economical, and, best of all, spent with a downy, gurgling, waddling baby vulture.

There are several other baby raptors in this book. All of them were found orphaned or injured and brought to wildlife rehabilitation organizations by citizens. The baby eastern screech-owl and great horned owls came into the Wildlife Rehabilitators Association of Rhode Island (who have been my partners in several book projects) and were transferred to Born to Be Wild Nature Center in Bradford, Rhode Island, an all-volunteer organization that is dedicated to the treatment, rehabilitation, and release of birds of prey. Born to Be Wild cares for about sixty-five raptors a year and gives more than eighty educational talks to both children and adults. Like many such facilities, Born to Be Wild is a labor of love, a couple's personal property converted to a sanctuary and treatment center for animals in need.

The dedication that it takes to devote one's life to rescuing wildlife is admirable no matter what the species, but raptors are not for the faint of heart. Their diet demands that caretakers have a large supply of small mammals available and often means

recycling roadkill, buying large quantities of frozen dead chicks, and slicing up mice like cucumbers.

I am an animal person, and I have spent much of my career working with other kindreds, but there are many varieties of animal people. You have dog people, who tend to be social and value loyalty and companionship; cat people, who are often introspective and subtle; horse people, who are rugged and adventurous; and even reptile people, who are eccentric and methodical. But raptor people are different. They're quiet and intelligent and have a secret fire in them. They are true nature lovers who appreciate both the beauty and brutality that are inseparable in the natural world. They are readers and thinkers and doers, which is what draws them to these remarkable animals.

Raptors

GOLDEN EAGLE

—

The golden eagle would win a raptor popularity contest, as it is the most common official national animal in the world; it is represented on the flags of Albania, Austria, Germany, Kazakhstan, and Mexico. It's no wonder that the golden eagle is a desirable symbol, as this massive raptor is impressive in both size and speed. With a wingspan of more than seven feet, the golden eagle has been clocked in aerial dives at two hundred miles per hour. The golden eagle also performs a territorial display and courtship ritual called "skydancing," where the bird executes a very rapid series of pendulum-like steep dives and upward swoops. Golden eagle couples often engage in aerial play, where one flies up with a stick or other object and then drops it for the other to catch.

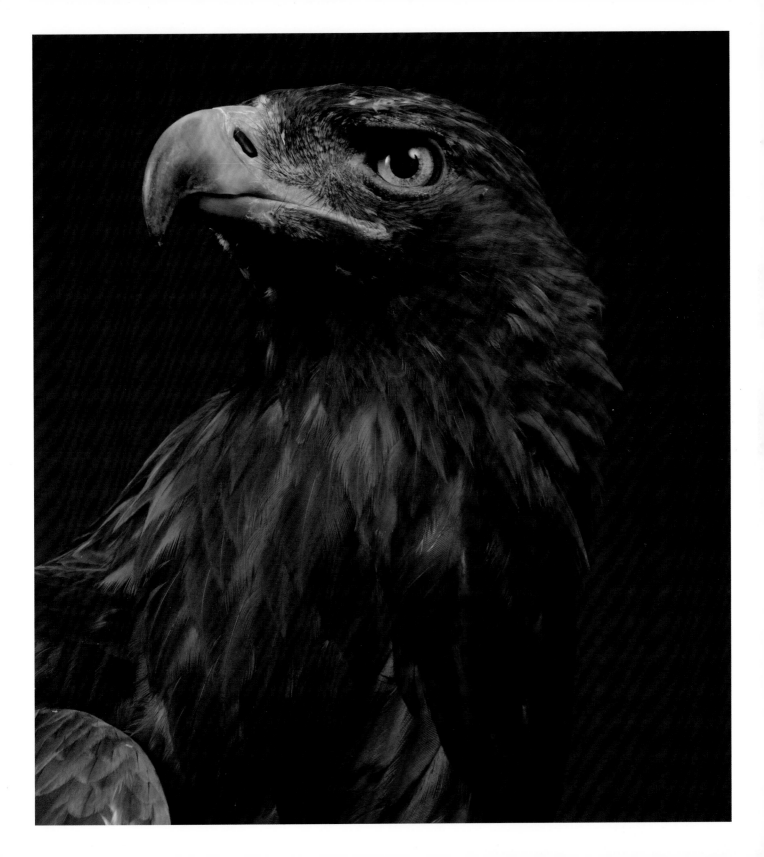

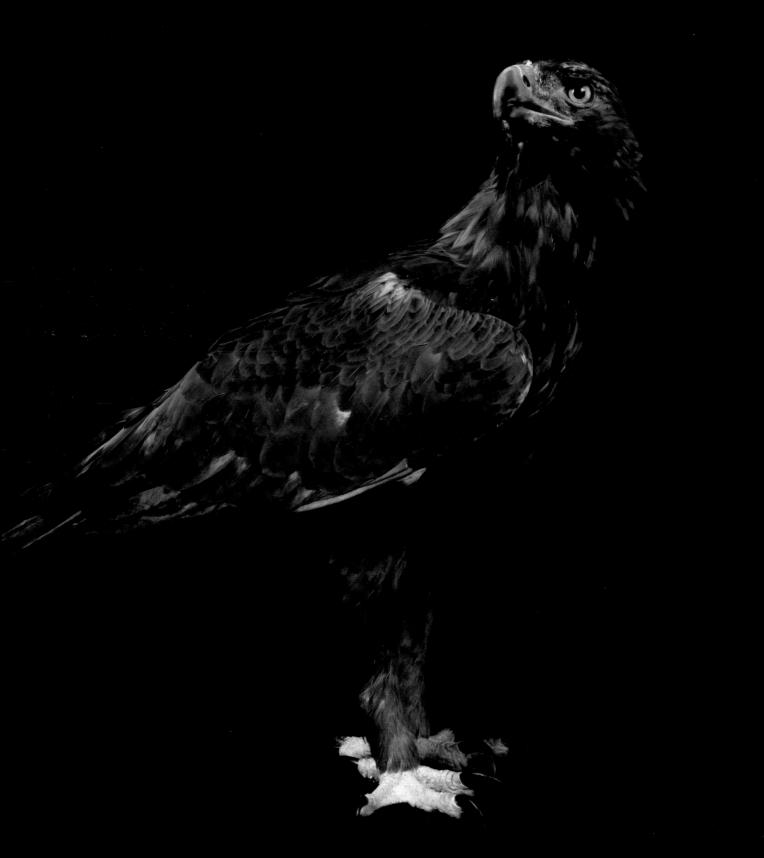

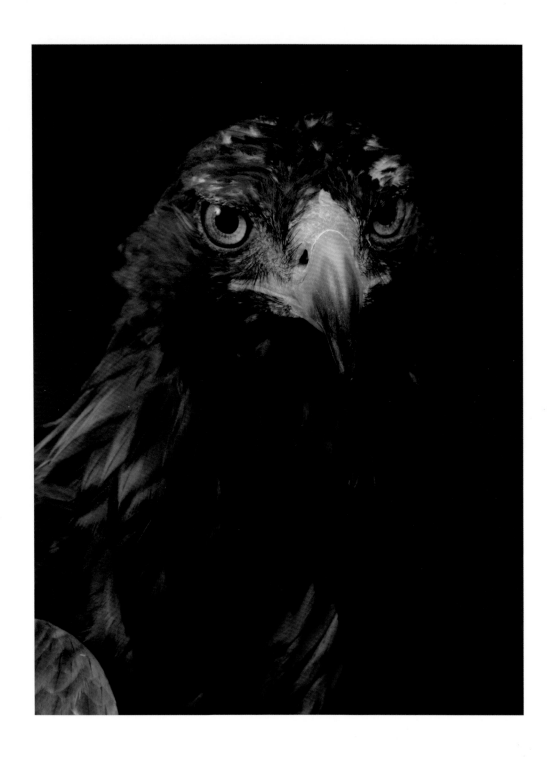

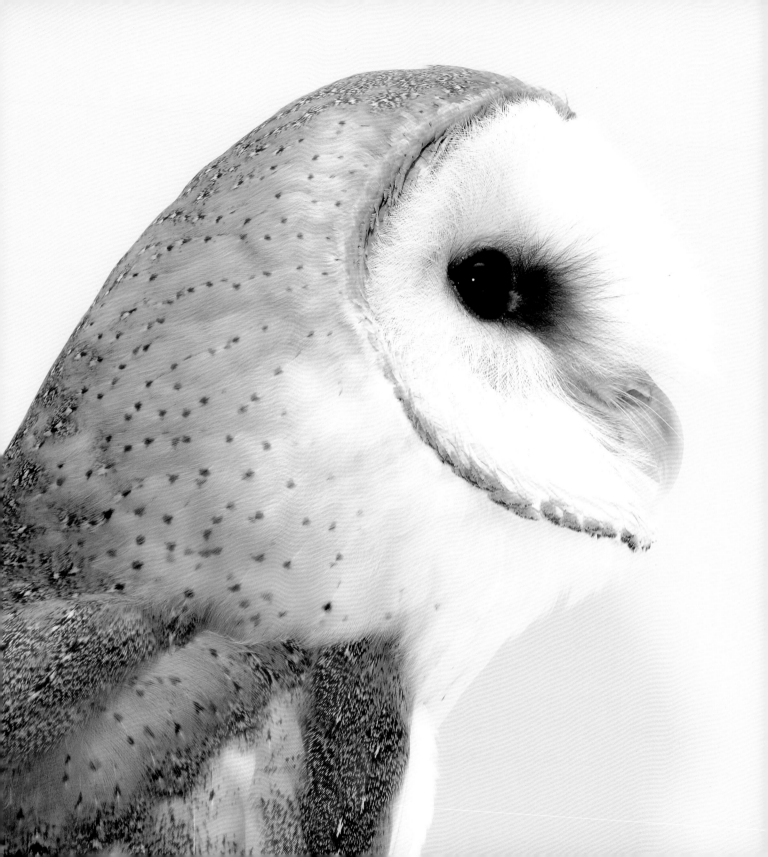

BARN OWL

—

Barn owls love the night life. In fact, like most owls, they are nocturnal and only fly and hunt at night. As their name implies, barn owls often like to roost during the day in old barns or abandoned buildings, where they wait until the sun goes down, then fly silently across fields using their amazing hearing to hunt small mammals in the grass. A barn owl's hearing is so keen that it can hunt even in complete darkness.

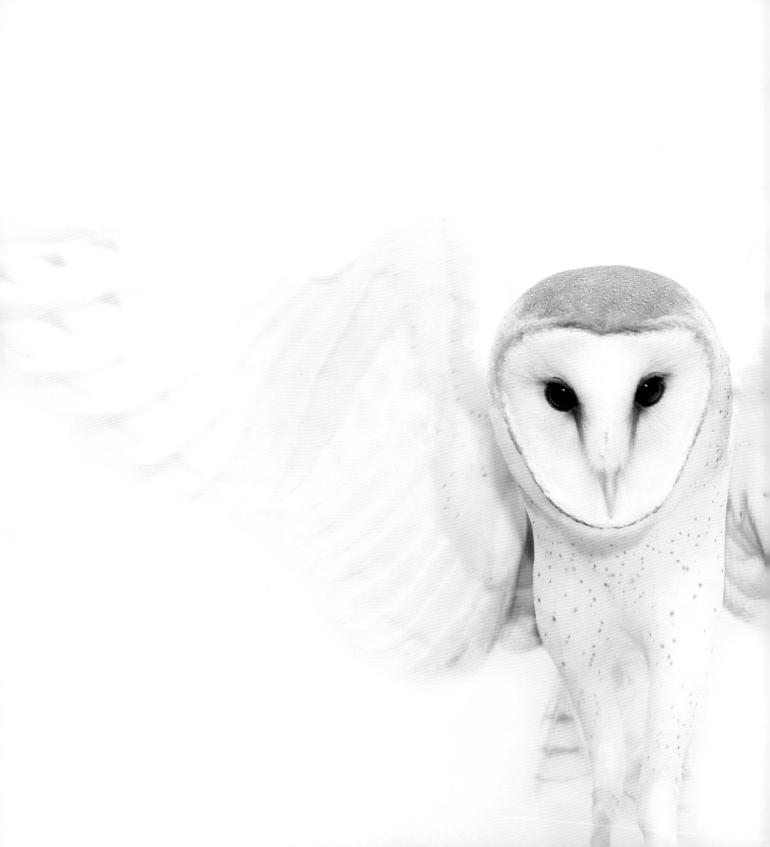

APLOMADO FALCON

—

The aplomado falcon almost pulled off a very convincing disappearing
act. The last known wild breeding pair of aplomado falcons in the United
States was seen in New Mexico in 1952. The population was thought
to have sharply declined over several decades due to the use of pesticides
like DDT. Aplomado falcons were finally placed on the endangered species
list in 1986, and a conservation group began an ambitious captive-
breeding and release program. Since then the program has succeeded
in releasing more than fifteen hundred birds, which has, over time, restored
a small breeding population of aplomado falcons to their native territory.
However, the birds still remain on the endangered species list.

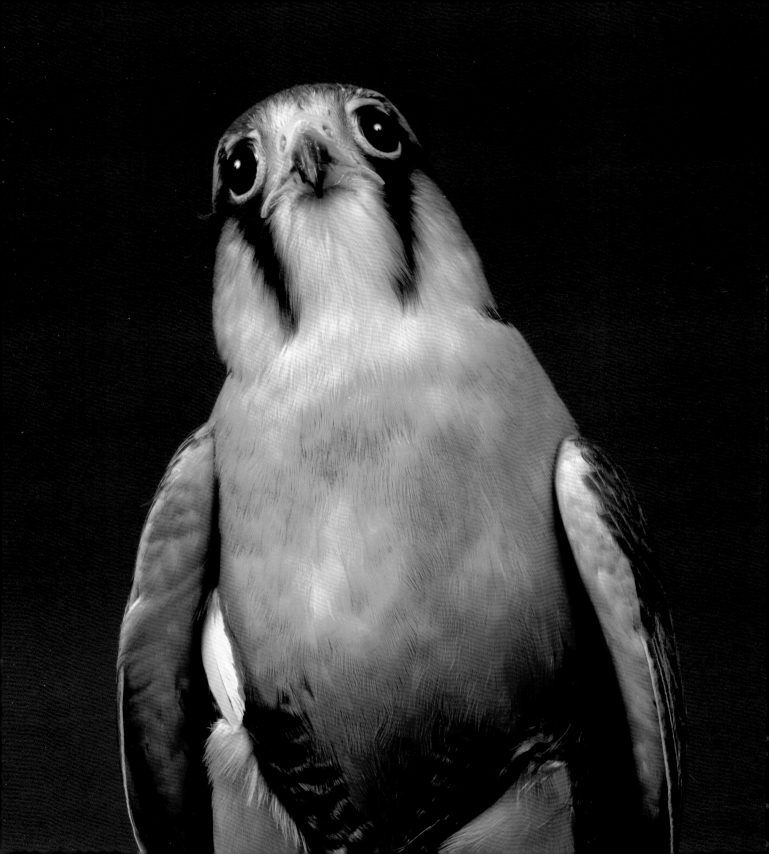

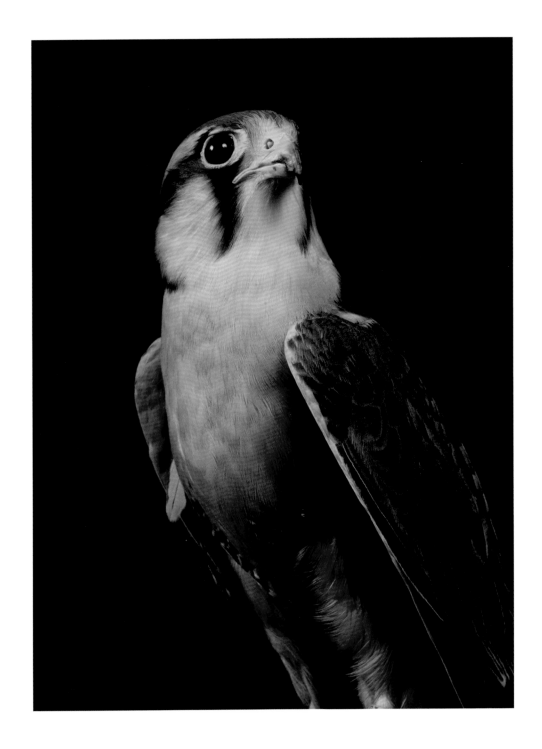

overleaf

BALD EAGLE

—

This fierce, iconic bird is actually quite the romantic. Bald eagles mate for life; during courtship, prospective mates perform cartwheels in the sky. Together they hook their talons and spin down from the sky toward the ground. They let go of each other before hitting the ground and then soar back up into the sky. Their nests are the largest of any North American bird, and the eagles often reuse them year after year until they are finally destroyed by wind or collapse from the weight of the inhabitants. The name "bald eagle" is somewhat misleading, as these birds are not actually bald but have heads covered in pure-white feathers.

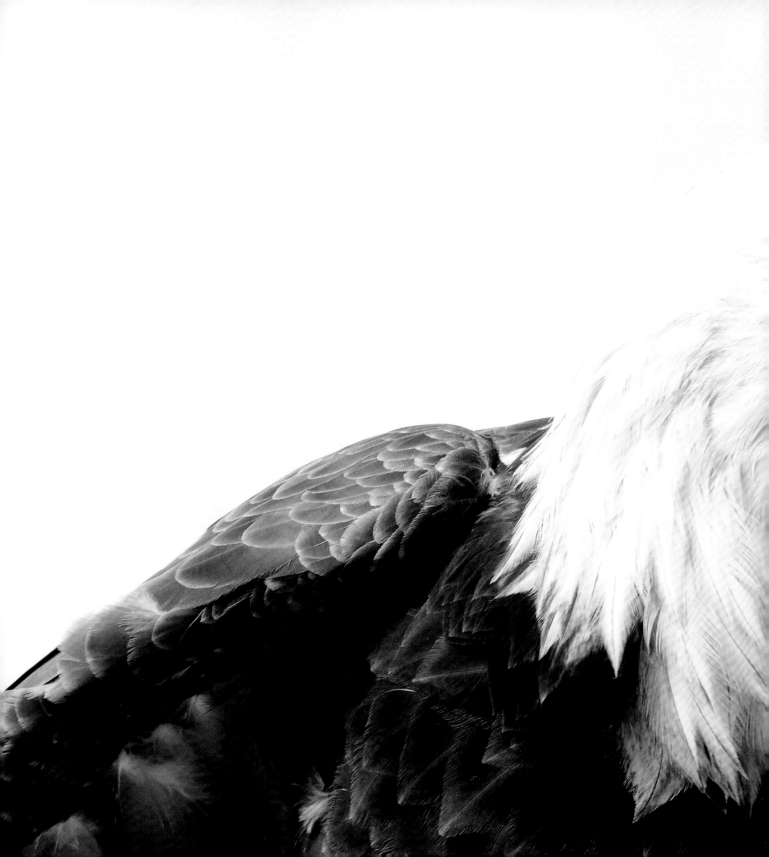

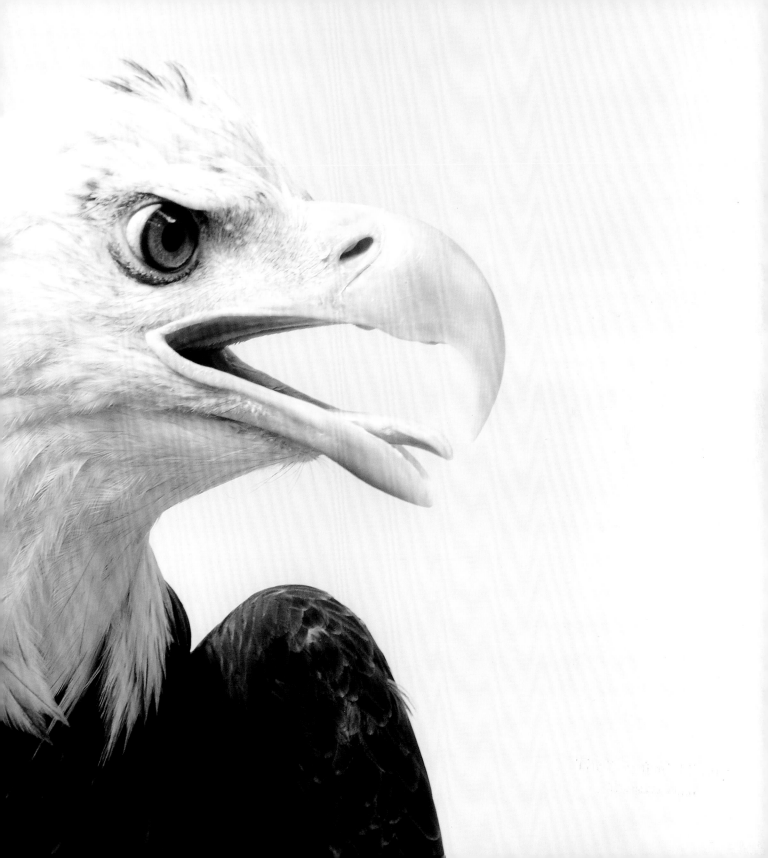

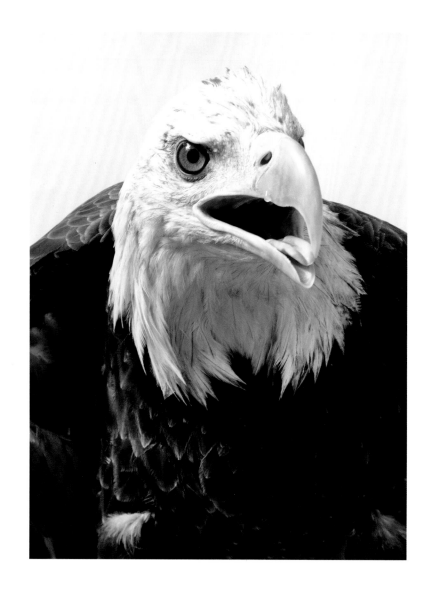

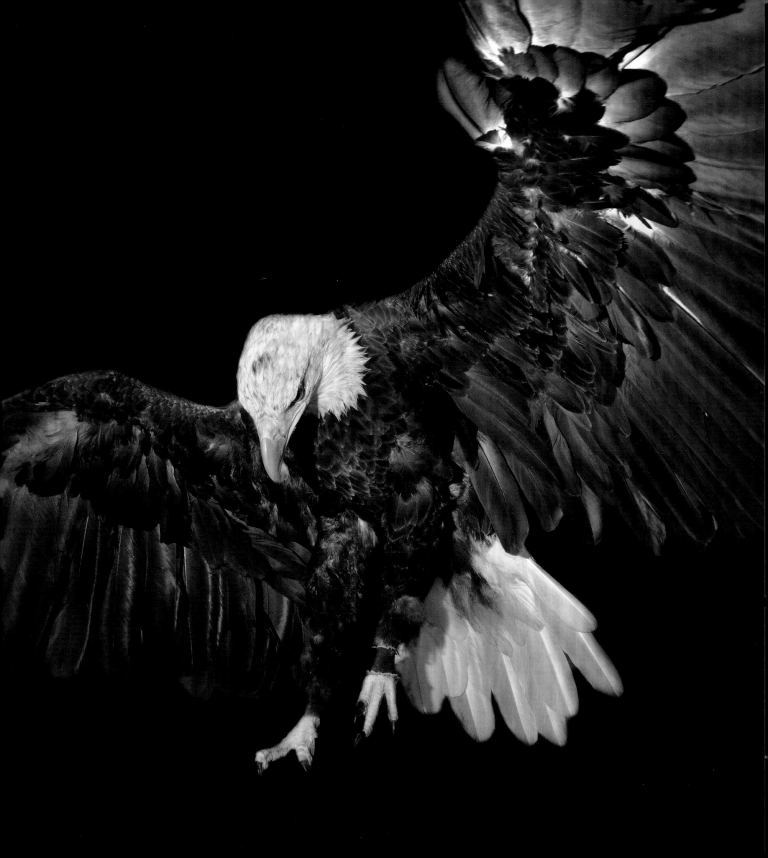

SWAINSON'S HAWK

—

The Swainson's hawk once suffered from a case of mistaken identity, when an early specimen drawing was misidentified as a common buzzard. Several years later, in 1832, the mistake was found and the species was named in honor of the illustrator who had first drawn the mislabeled specimen. Swainson's hawks are highly social and tend to be found in large groups for much of the year. Groups of soaring or migrating hawks are called kettles; Swainson's hawks often form kettles consisting of tens of thousands of individuals during their migration from North to South America.

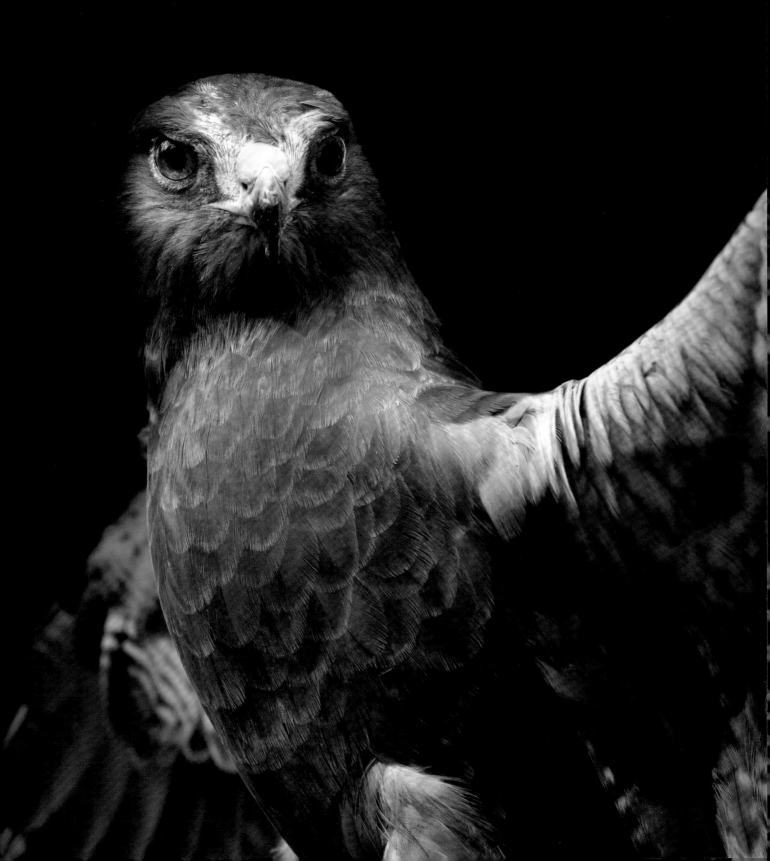

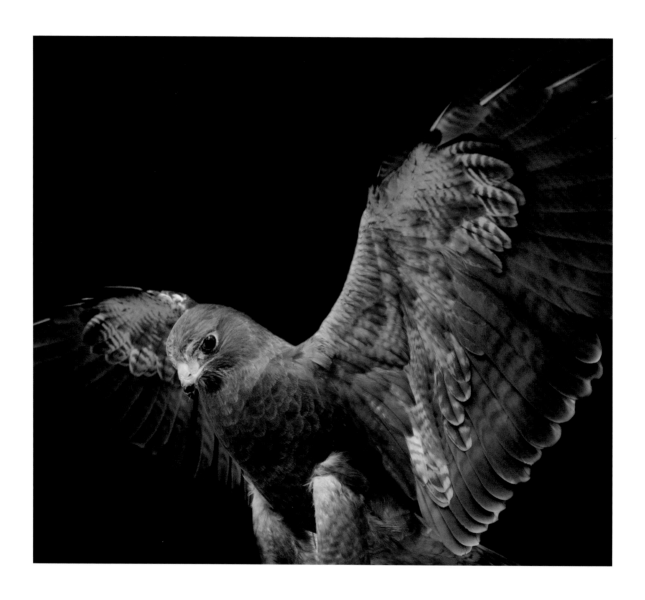

overleaf

GREAT HORNED OWL

—

Great horned owls are not as harmless as they look. These tufted, large-eyed fluffballs are actually incredibly fierce and voracious predators. Great horned owls have the most diverse diet of any North American raptor and eat everything from small rodents to skunks, geese, porcupines, other raptors, and even housecats. The grip of a great horned owl is immensely powerful: when clenched, its talons require a force of twenty-eight pounds to open. This strength comes in handy for crushing the spines of large prey.

When it comes to nesting, they like to recycle. This large owl does not make its own nest but instead often recycles the old nests of other birds or small mammals.

Great horned owl nestlings, like the two-week-old chick on pages 38 and 40, are still covered with down but will begin growing their primary feathers at three weeks old. Chicks usually begin to leave the nest or "fledge" when they are between six and eight weeks old. The chick on page 39 was about six weeks old when photographed.

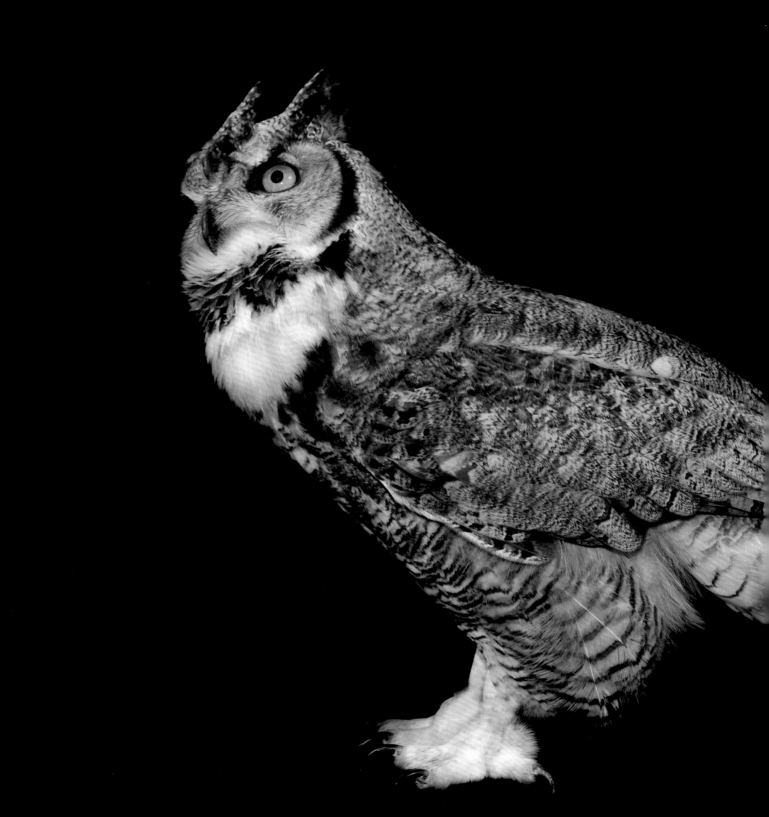

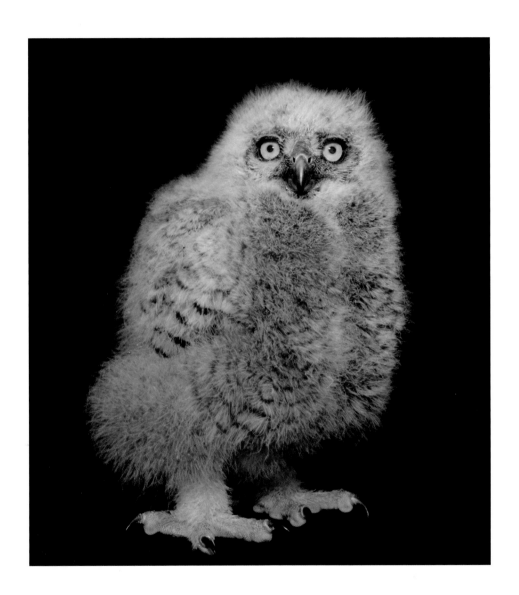

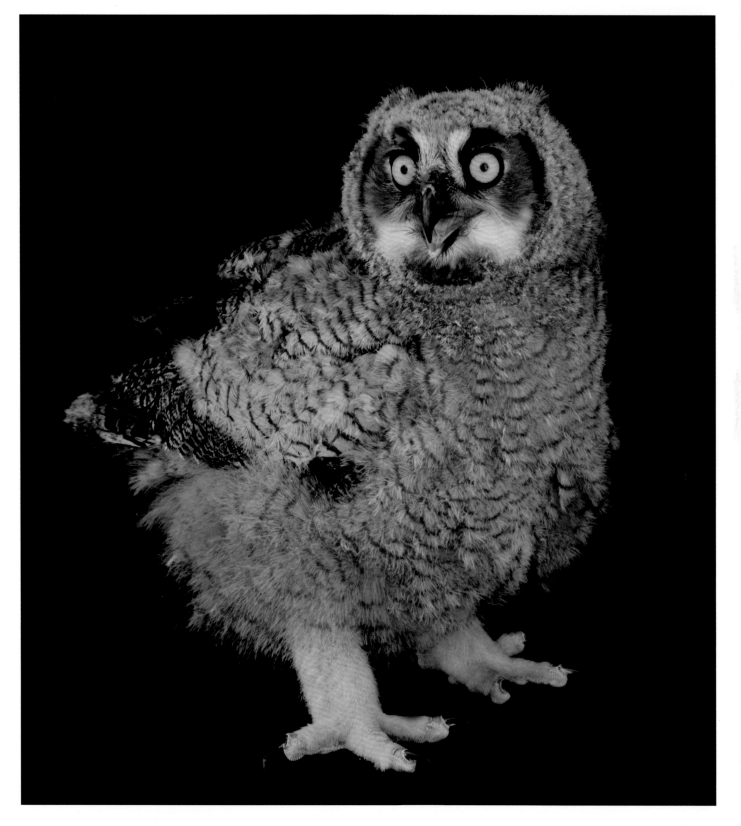

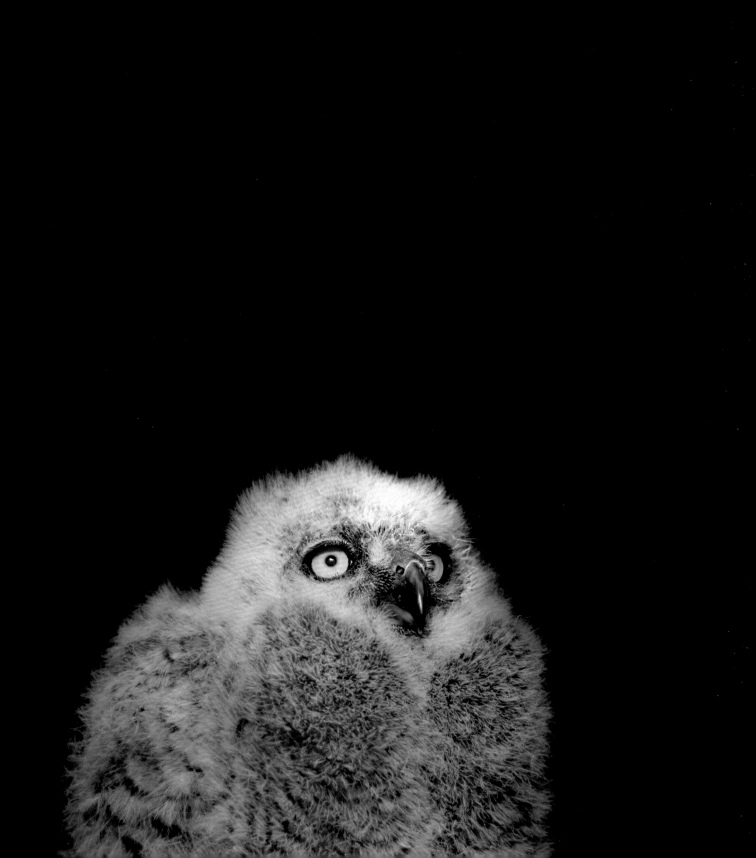

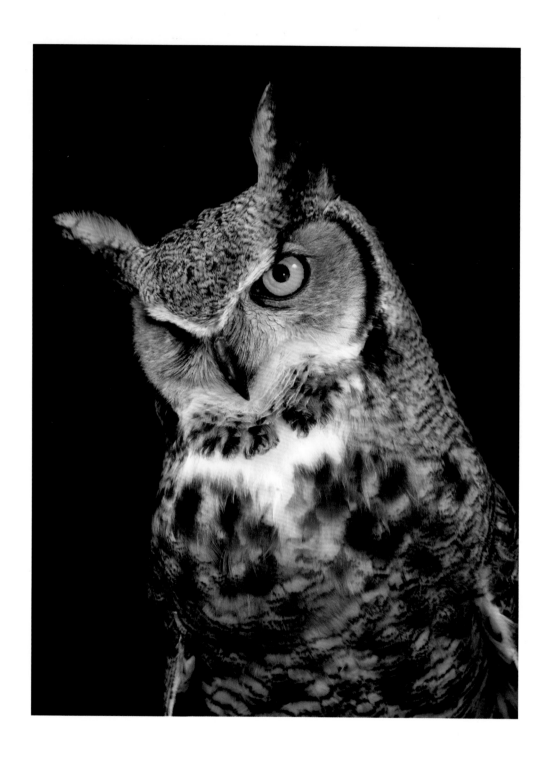

HARRIS'S HAWK

—

The striking brown and red Harris's hawk is a real team player. Harris's
hawks are considered the most gregarious of all raptors and often
form complex social structures of up to seven birds who hunt and tend
nests cooperatively. One of the biggest threats to Harris's hawks is
accidental electrocution from unprotected power lines, which the birds
try to perch on. In some cases members of the hawk's social group
have been observed bringing food to injured family members. Because
of their intelligence and cooperative nature, Harris's hawks are very
popular birds for falconers.

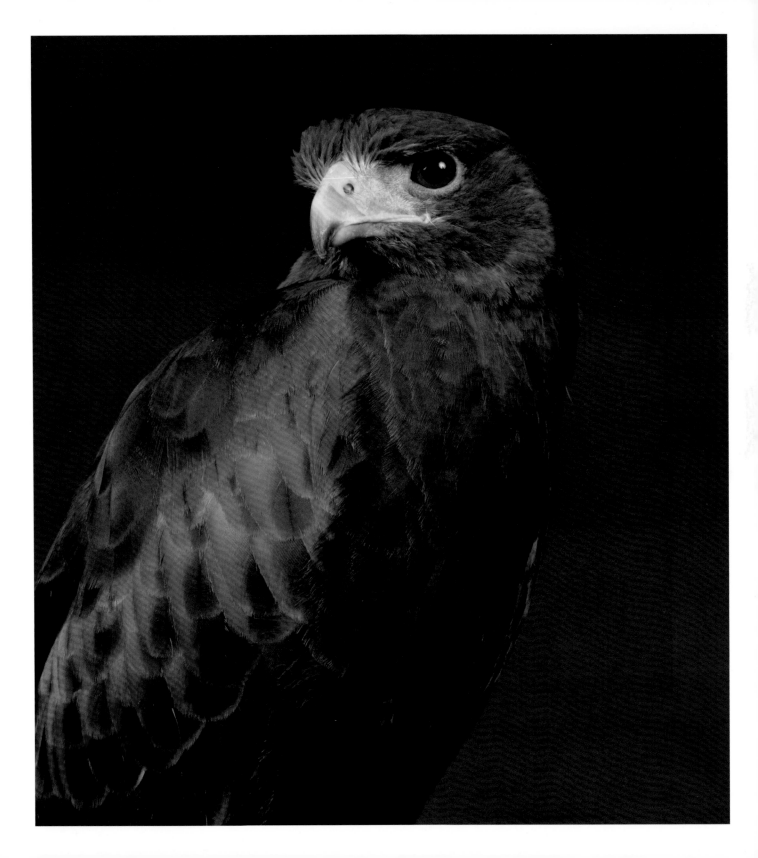

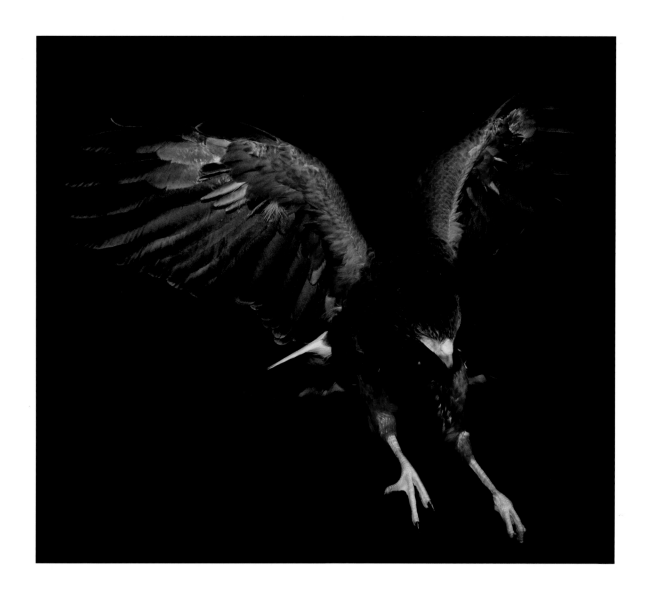

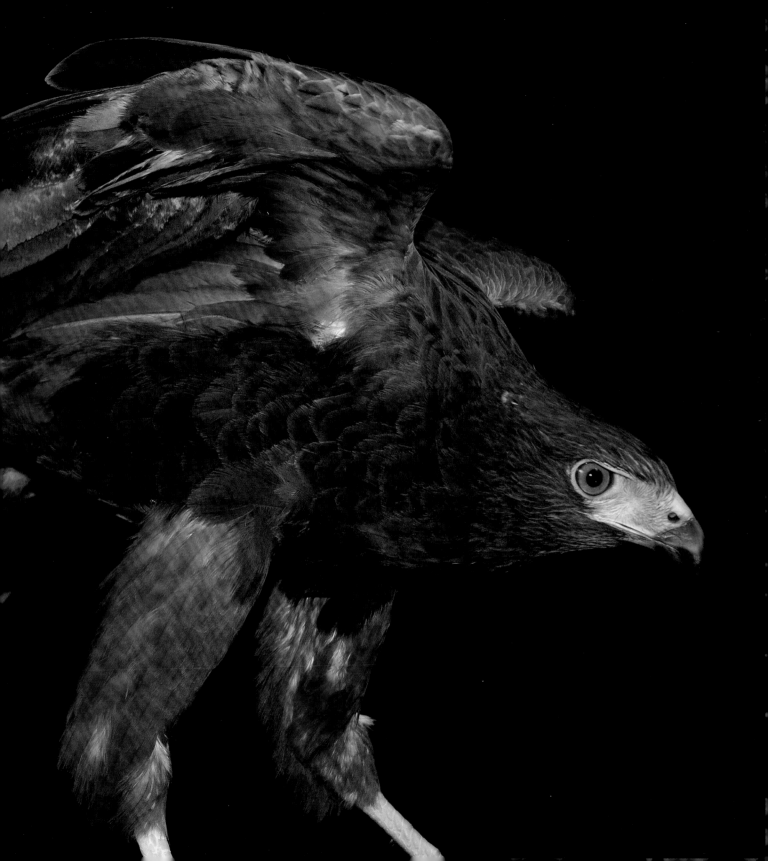

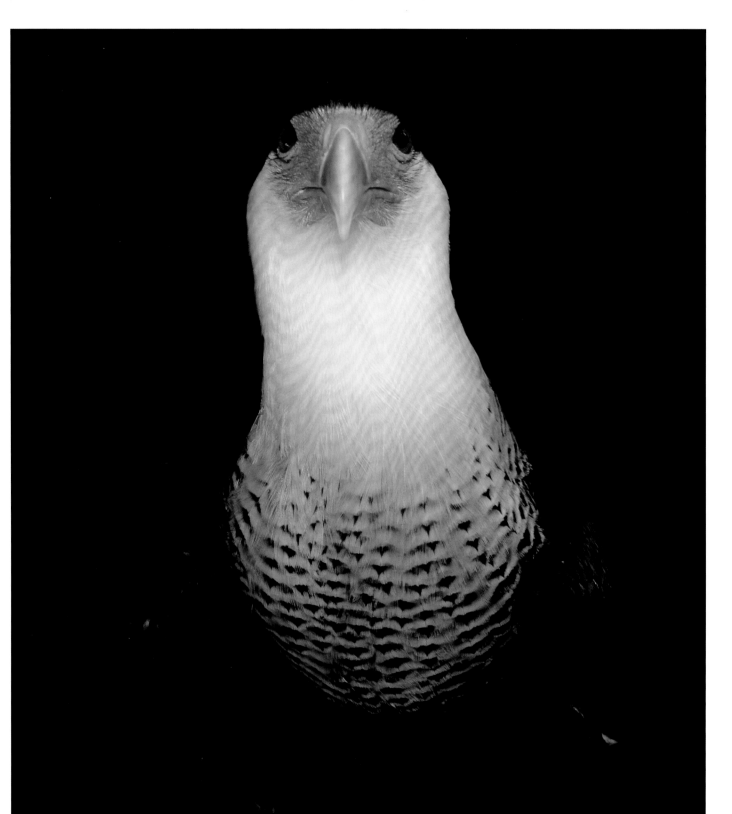

CRESTED CARACARA

—

The exotically colored crested caracara is a flashy opportunist. The caracara hunts and scavenges, often feeding on carrion that has been snatched from vultures. They are known for preying on small animals who are wounded or sick; they also will scratch the ground to dig up insects or even turtles' eggs. Although often considered a tropical vulture, the crested caracara is most closely related to the falcon. The bird is also a common subject of ancient South American folklore, where it is referred to as a "Mexican eagle."

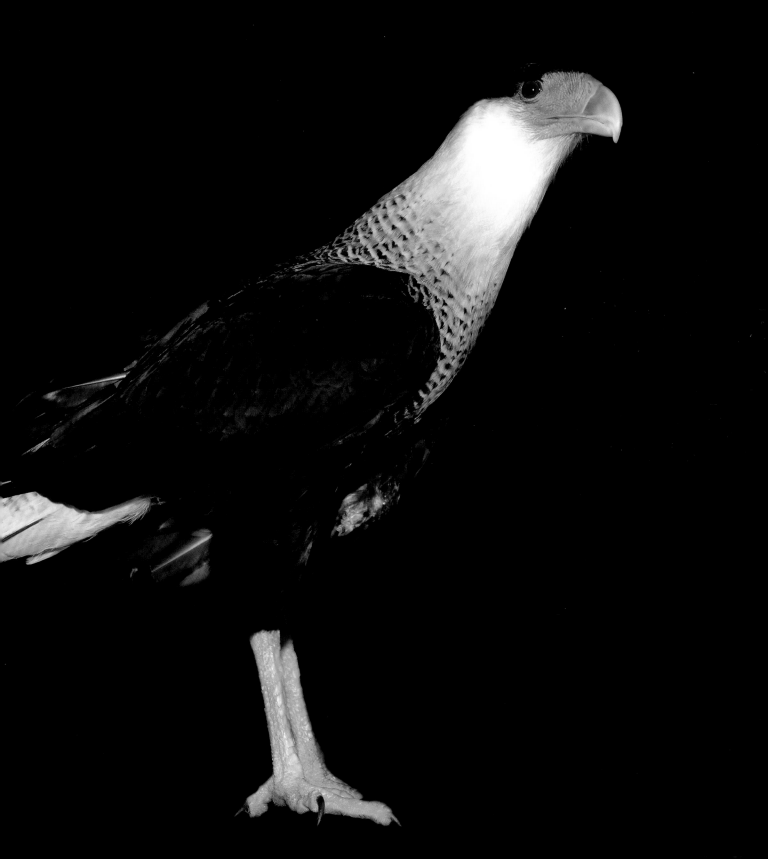

NORTHERN SAW-WHET OWL

—

These tiny owls with catlike faces are no pussycats. Like all raptors, they have strong, sharp talons for killing prey and a hooked upper beak for tearing meat. Small but mighty, the saw-whet grows to be only about seven inches tall. Its unusual name comes from its unique call, a high-pitched hooting that has been said to sound like a saw being sharpened on a whetting stone. Strictly nocturnal and found across North America, the saw-whet owl makes its nest in tree cavities in coniferous forests. Woodpeckers' holes are a favorite nesting spot for these petite owls, who can lay up to six eggs in one clutch.

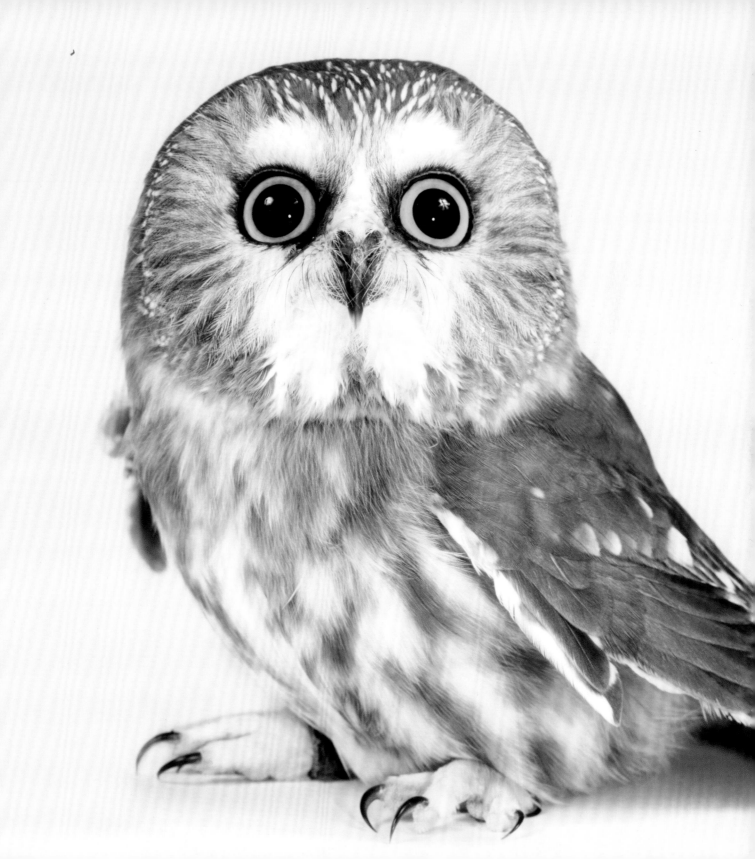

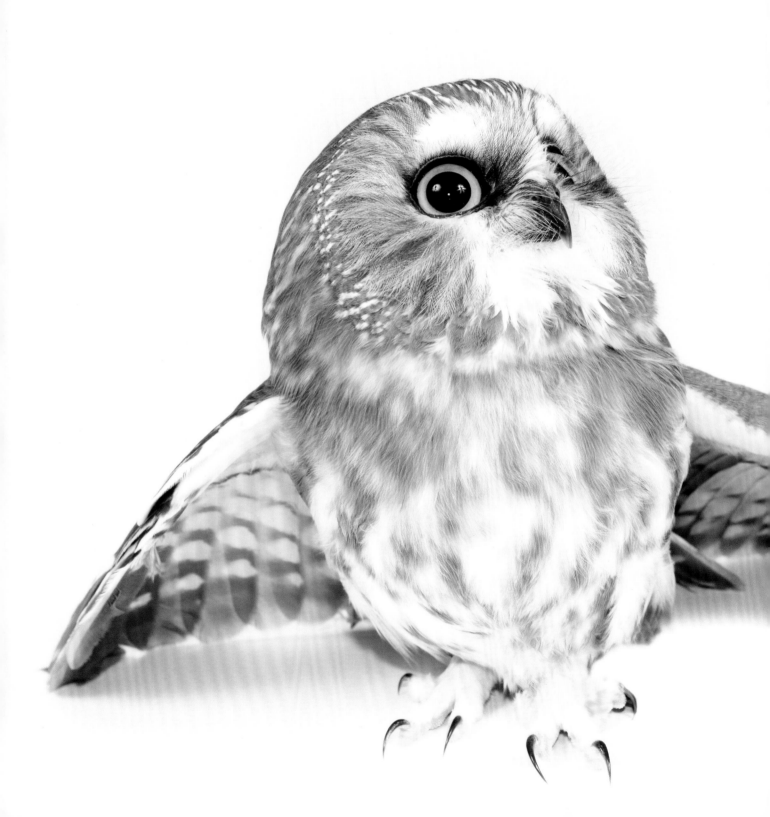

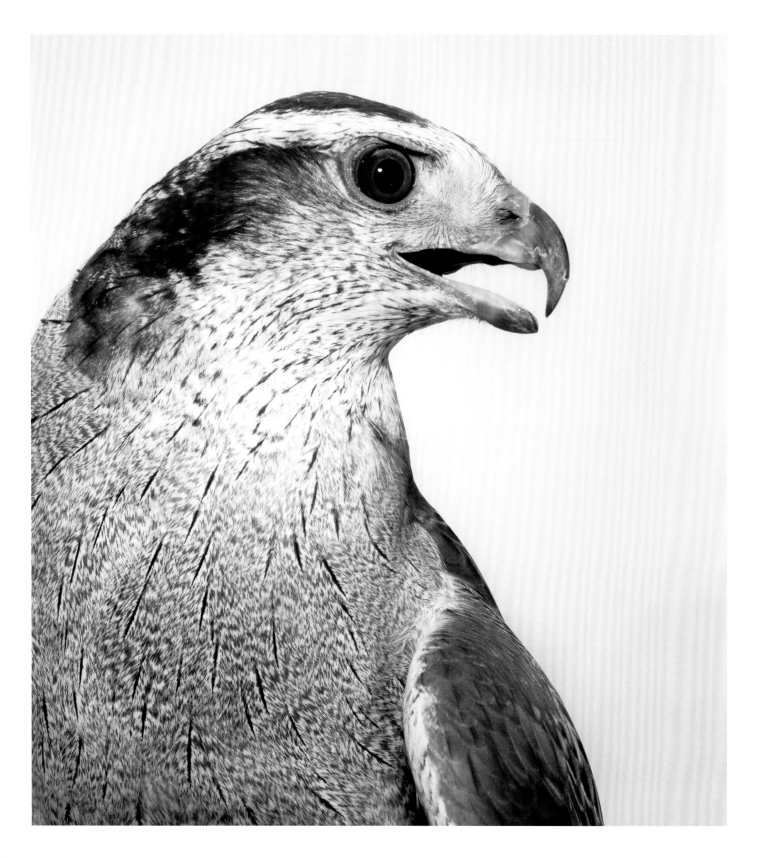

NORTHERN GOSHAWK

—

This fierce, secretive hawk likes to keep to itself. Although the goshawk is widespread across the Northern Hemisphere, it is not often spotted and usually lives in solitude. A favorite with falconers, goshawks have been trained to hunt with people for more than two thousand years. Falconers frequently claim that these birds are more psychologically complex than other raptors and require a special mutual understanding in order to be trained. The goshawk's tendency to prey on other birds is reflected in its name, which comes from the Old English word for "goose hawk."

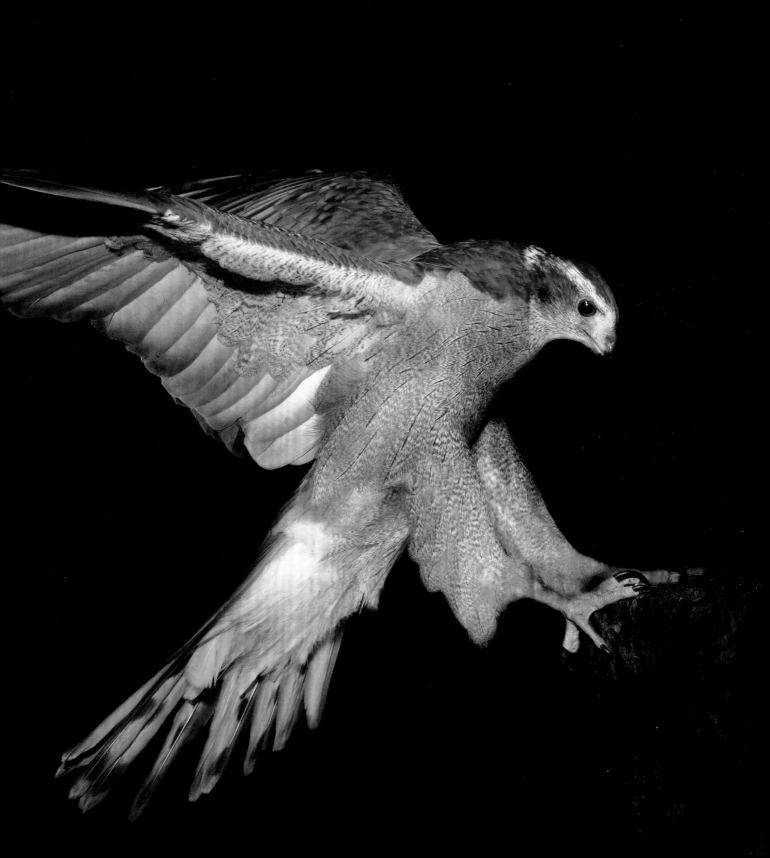

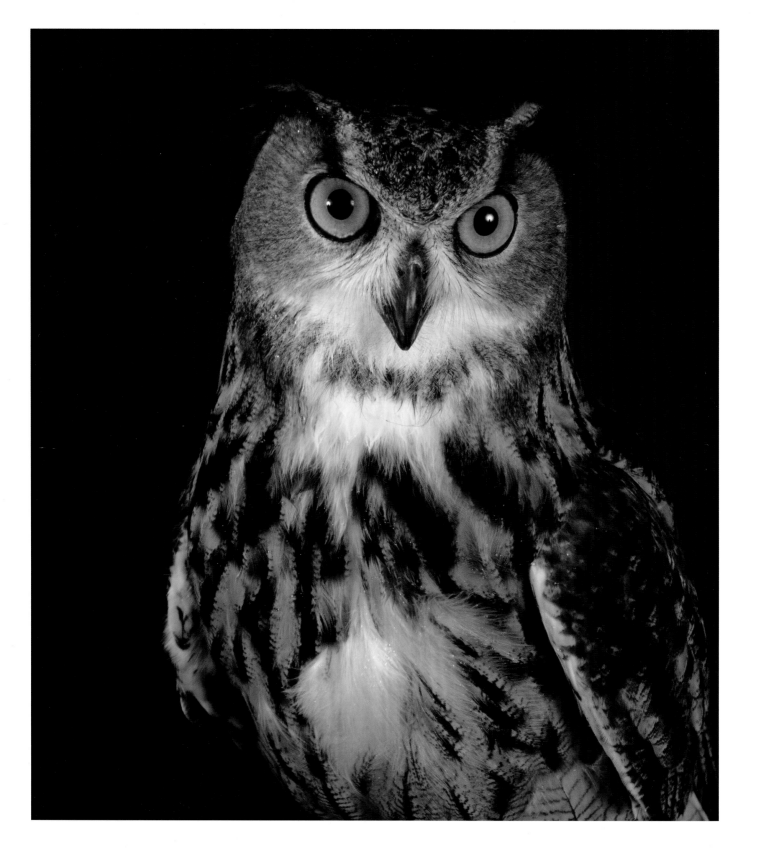

EURASIAN EAGLE-OWL

—

This hefty owl is not a picky eater. When it comes to hunting, the Eurasian eagle-owl will eat just about anything it can find, from beetles to young deer. These owls have been known to feast on herons, foxes, hares, and even other birds of prey. Eurasian eagle-owls who live near the ocean generally live on a diet consisting primarily of seabirds. This indiscriminate hunter does have a softer side, though. Eurasian eagle-owls have a wide range of vocalizations that help them assert territory, scare off potential threats, and secure a mate. During courtship, male Eurasian eagle-owls often perform a duet with their partner.

BLACK VULTURE

—

Black vultures prefer to be seen and not heard. These giant scavengers do not have a voice box, so their vocalizations are limited to hisses and grunts. They are monogamous; not only do they stay with the same mate year after year, but, unlike most birds, black vultures remain with their mate year-round. They are doting parents; chicks like the three-to-four-week-old nestlings on pages 61, 64, and 65 will be fed regurgitated food by both parents until leaving the nest. They form large communities of individuals and roost communally at night. Black vultures are native to the southern United States and South America.

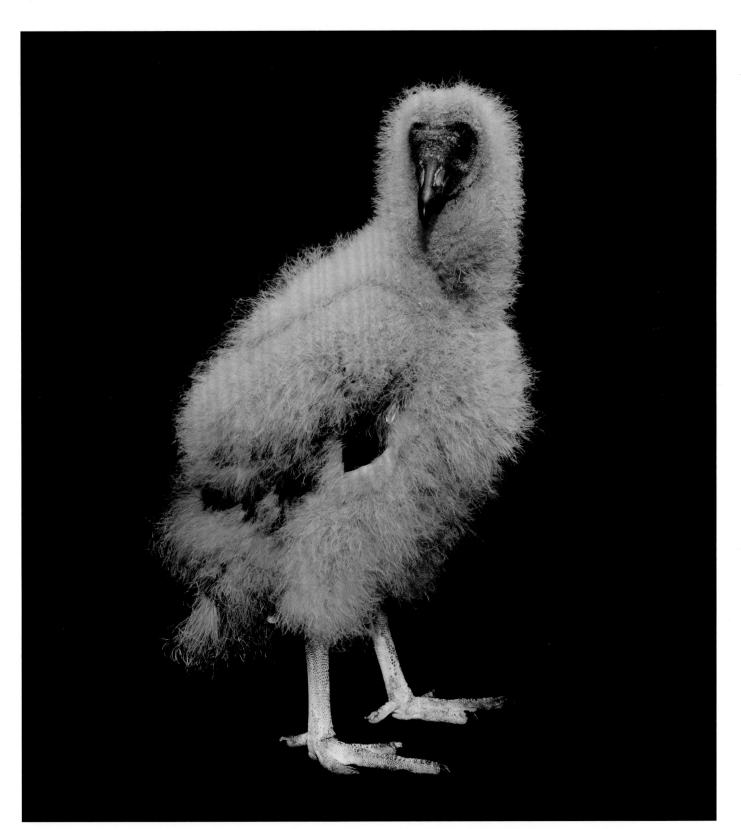

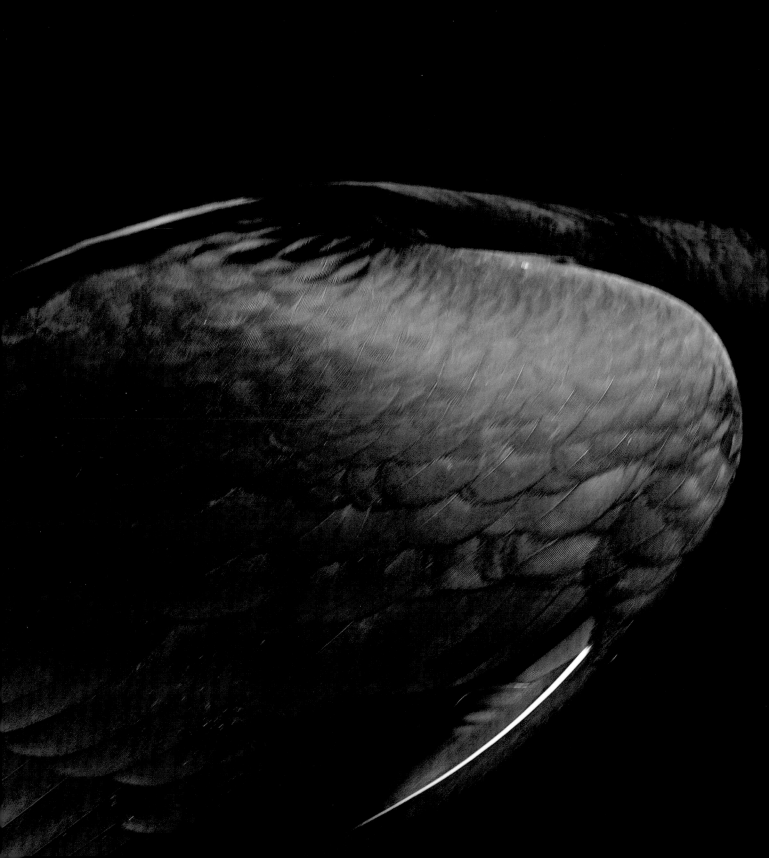

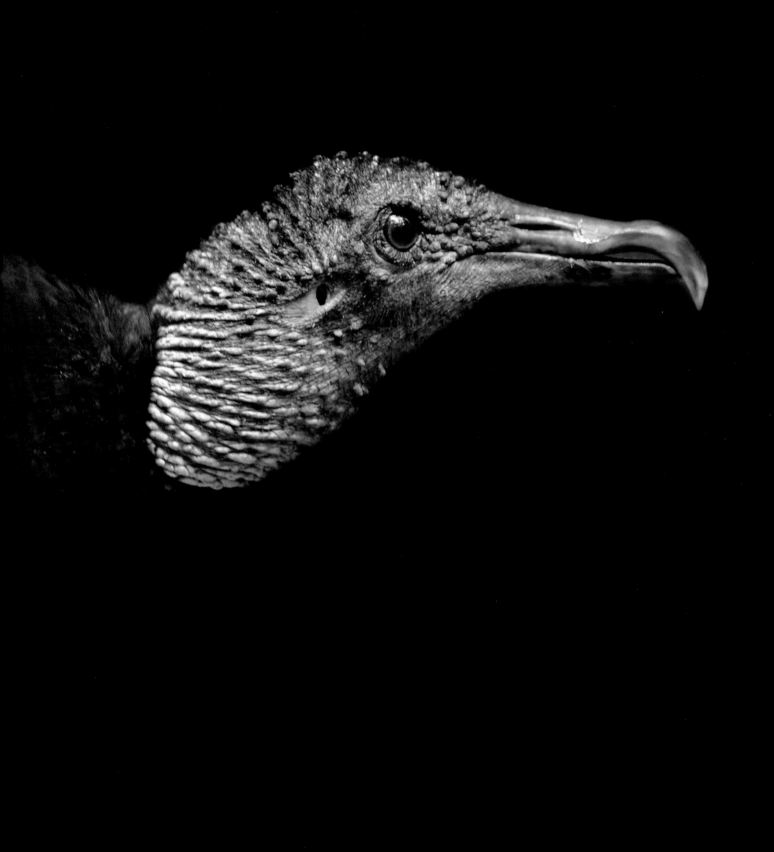

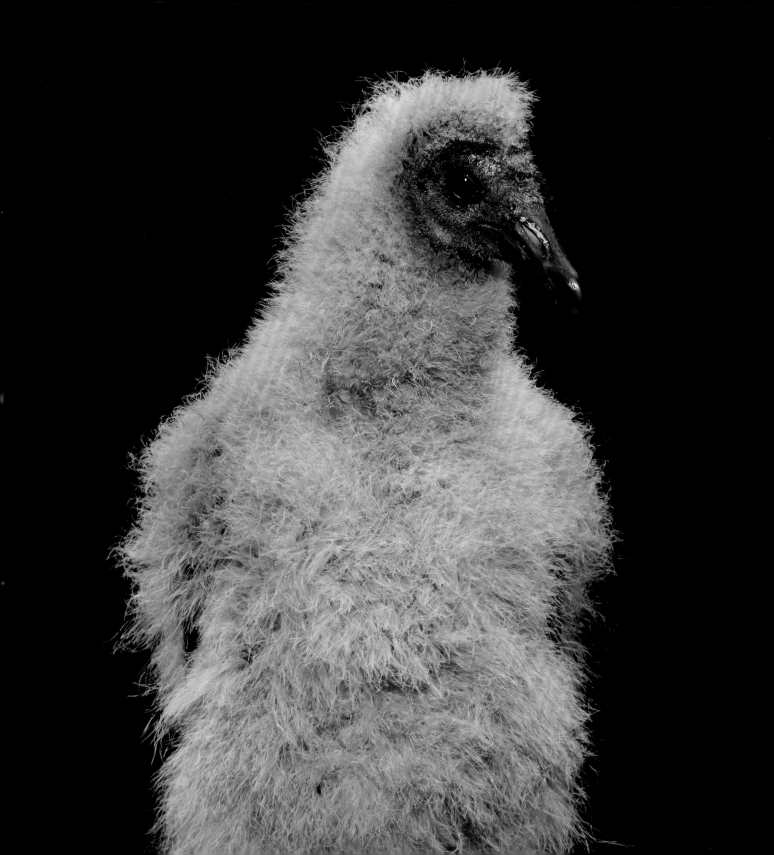

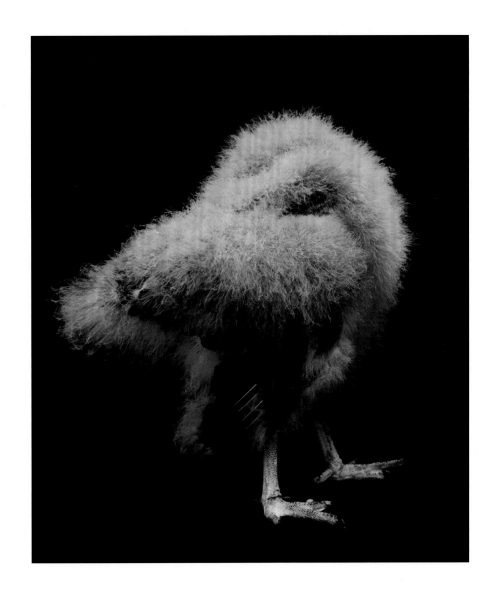

BARRED OWL

—

Barred owls are homebodies. Unlike other owls that migrate or have a vast territory, most barred owls will stay within a six-mile area their whole lives. This is perhaps due to their very specific nesting needs. Barred owls make their nests in large dead trees, which are most often found in dense, mature forests. The barred owl is sometimes called the laughing owl due to its many vocalizations. Its famous hooting sequence has been said to sound like the phrase "Who cooks for you? Who cooks for you all?" The biggest predatory threat to the barred owl is the great horned owl, which will eat barred owl eggs, babies, and even, occasionally, adults.

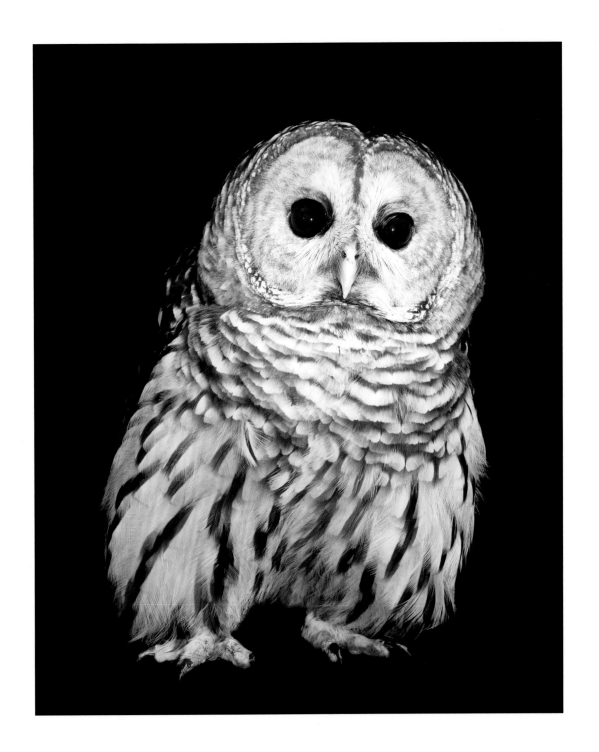

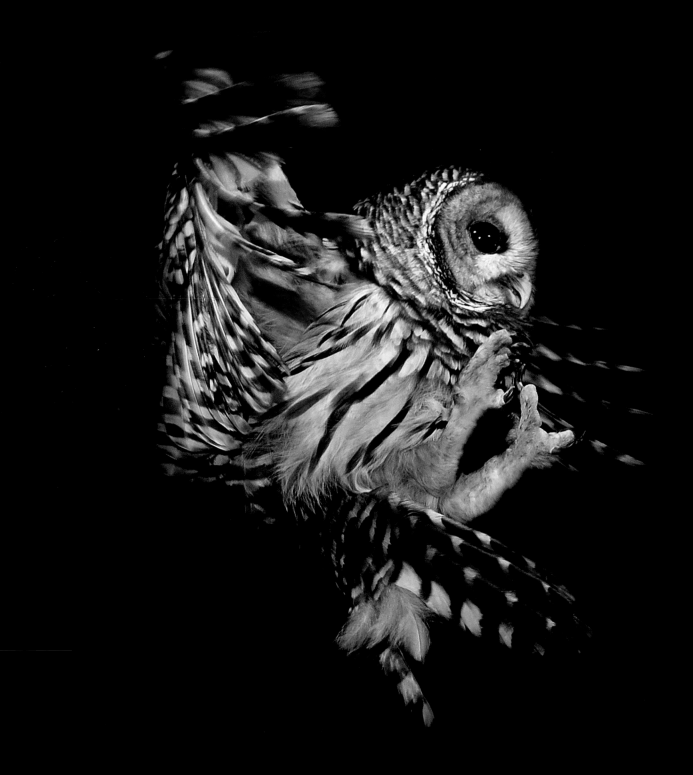

KING VULTURE

—

These brightly colored scavengers were once given the royal treatment.
Found between southern Mexico and northern Argentina, the king vulture
is said to derive its name from a Mayan legend that claimed the bird was a
king who delivered messages between humans and the gods. King vultures
are depicted in many Mayan codices, or folding books. Like all vultures,
the king vulture plays a crucial role in the ecosystem. By feeding on carrion
that would otherwise be a breeding ground for bacteria, vultures help to
keep disease in check.

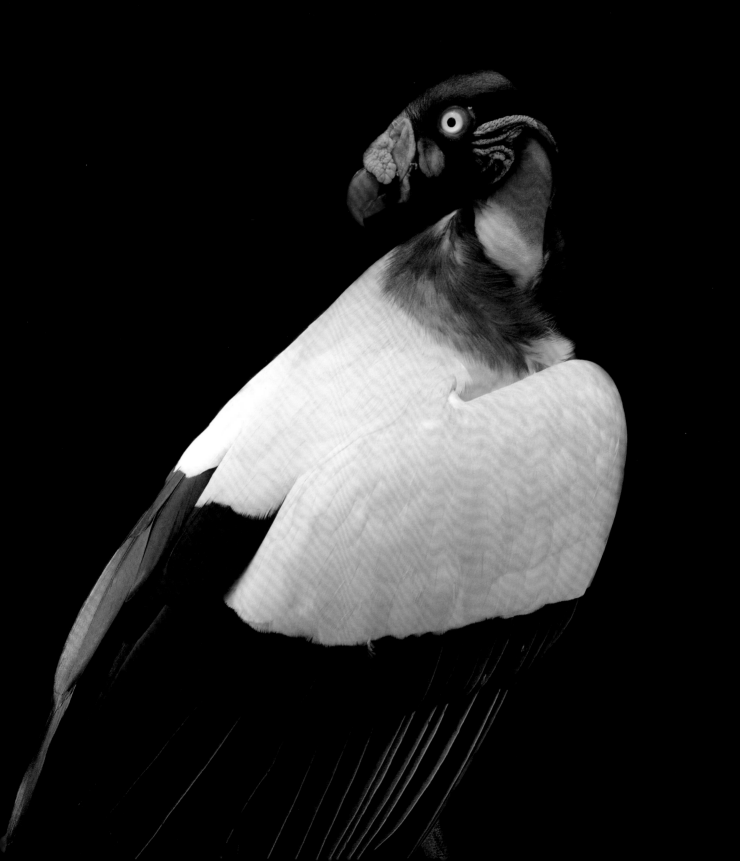

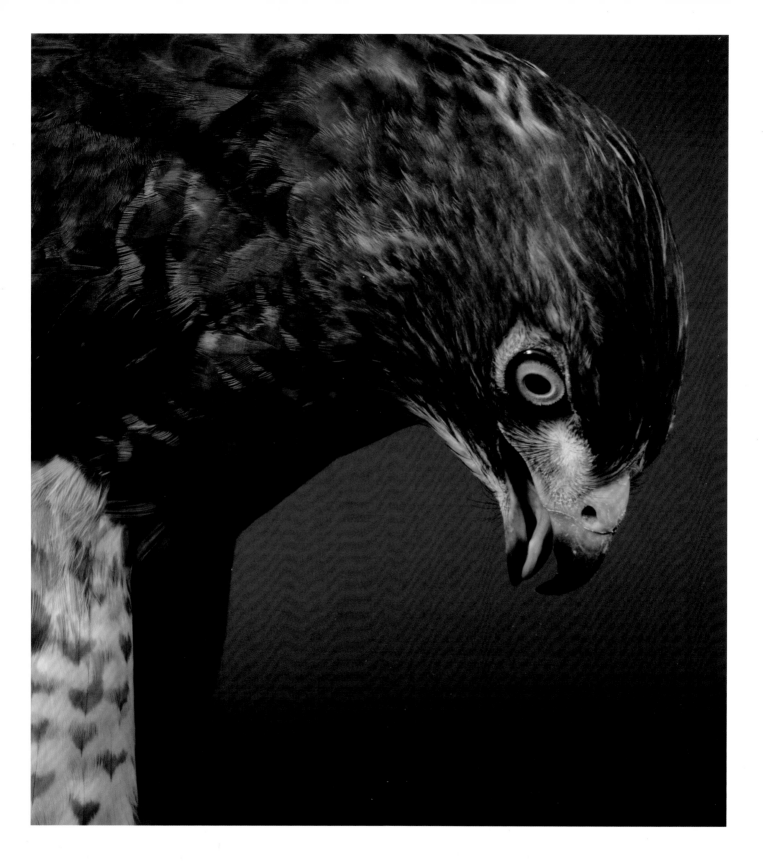

BROAD-WINGED HAWK

—

Broad-winged hawks believe in safety in numbers. Every fall hundreds
of thousands of broad-winged hawks form huge flocks and migrate
together from the forests of North America to South America. These
groups of birds can contain tens of thousands of individuals, and as
they progress to more narrow parts of Central America, they fly closer
together. People who have witnessed this impressive phenomenon in
places like Panama and Mexico have described it as "a river of raptors."

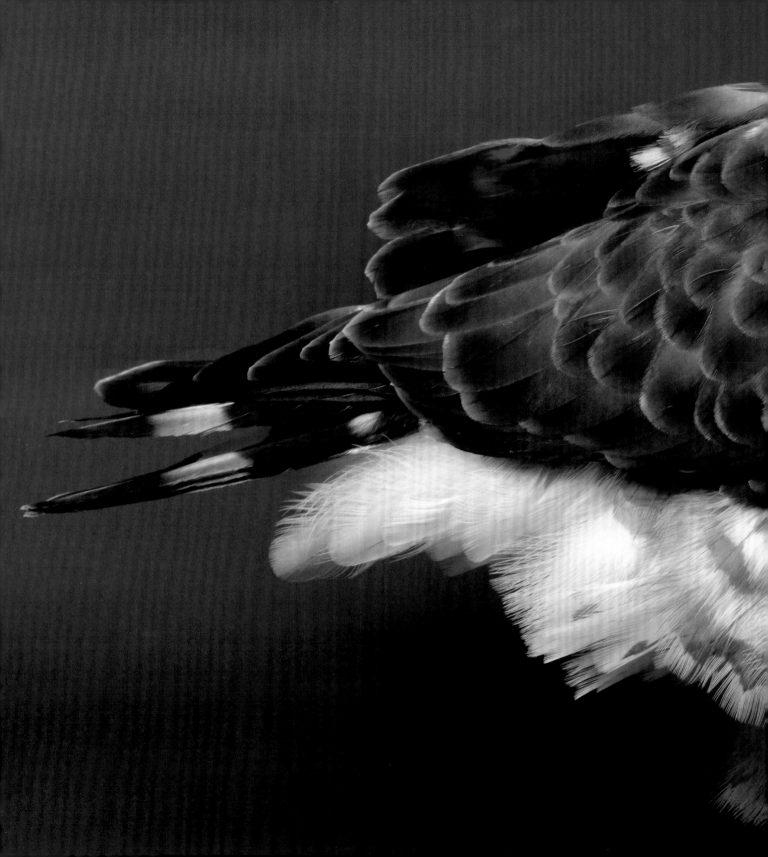

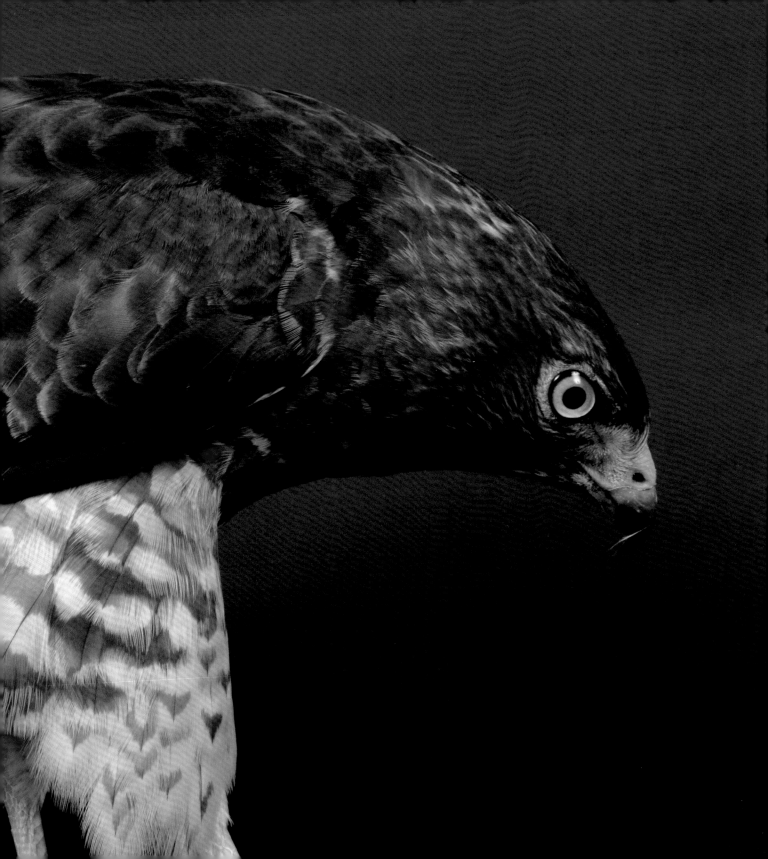

PEREGRINE FALCON

—

Peregrine falcons are ancient hunters who almost didn't survive the twentieth century. A favorite with falconers, peregrines have been used for hawking for more than three thousand years. Whether hunting with humans or in the wild, peregrines were prolific for millennia, but quite suddenly, due to the use of pesticides like DDT, the peregrine became a critically endangered species in the 1950s. The pesticides effectively reduced the amount of calcium in their eggshells, causing fewer and fewer chicks to survive. Fortunately, thanks to worldwide recovery efforts and a DDT ban, the peregrine was removed from the endangered species list in 1999.

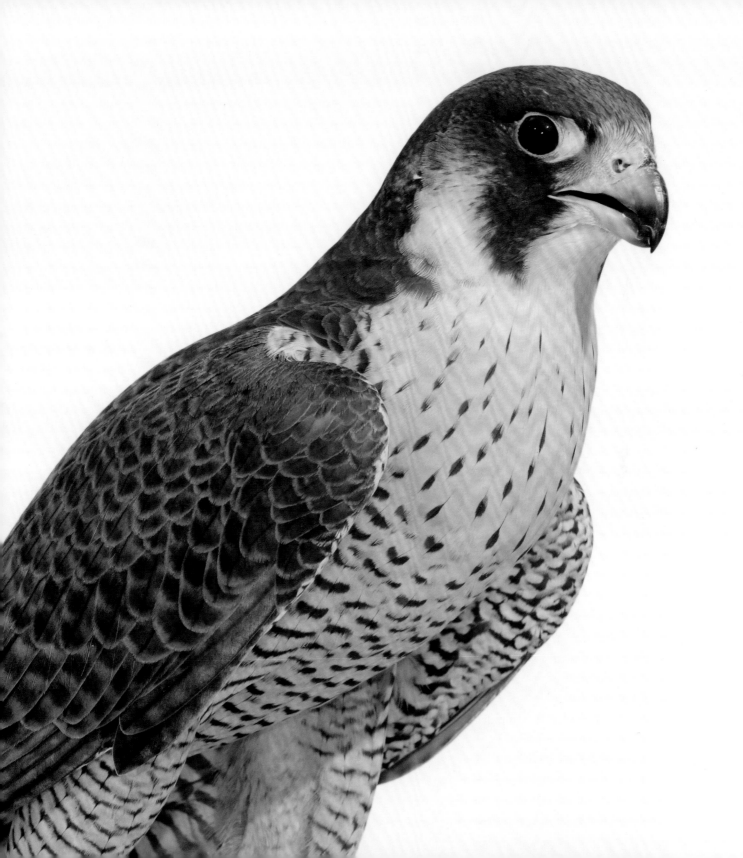

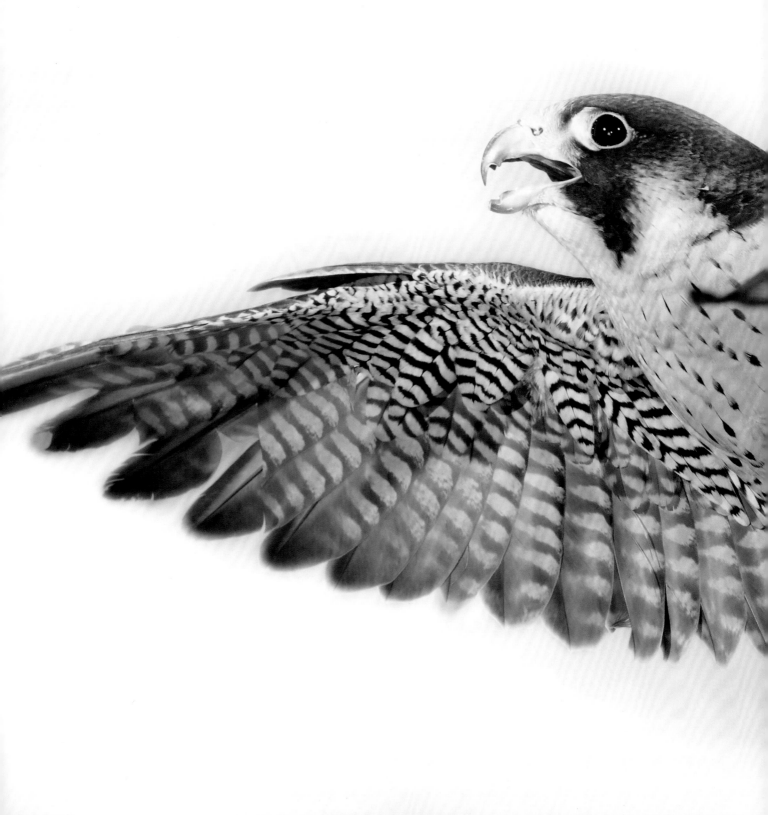

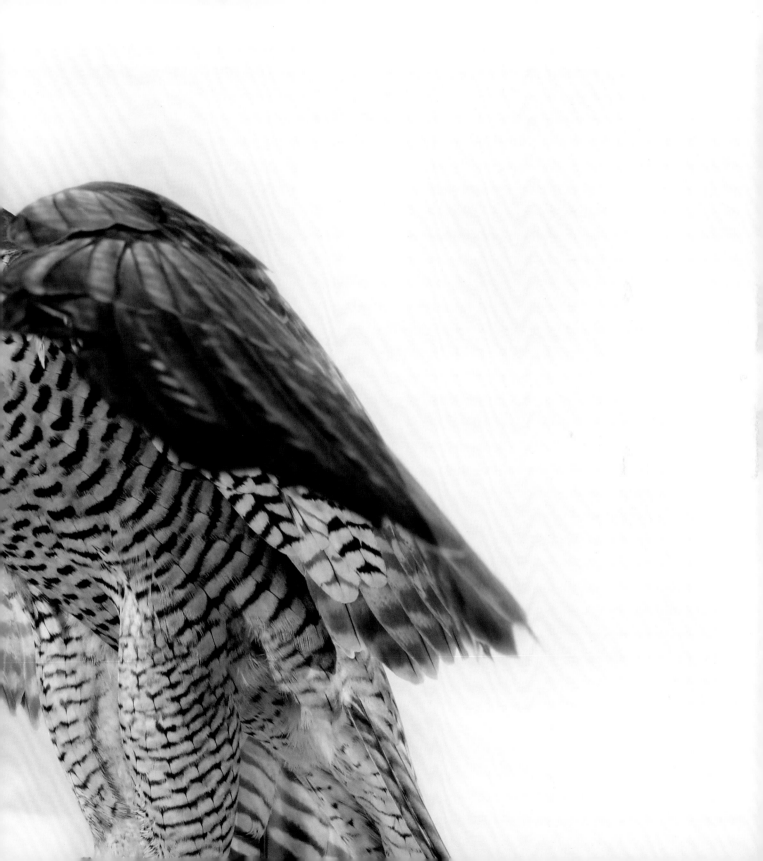

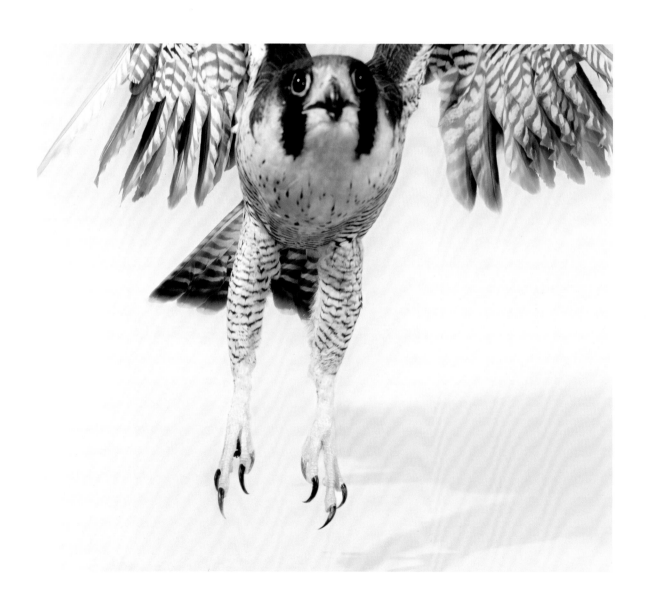

overleaf
RED-TAILED HAWK
—

Red-tailed hawks possess the official call of the wild. Their cry, which sounds like a rasping scream, is the most frequently used and misused "raptor" sound effect in movies and television. Quite often, the red-tail's cry is used as a vocalization for a completely different species—an eagle, falcon, or other raptor—just because it sounds wild. The red-tailed hawk is an extremely common raptor found in almost every open habitat in North America. Despite its nickname, "chickenhawk," the red-tailed hawk eats primarily rodents.

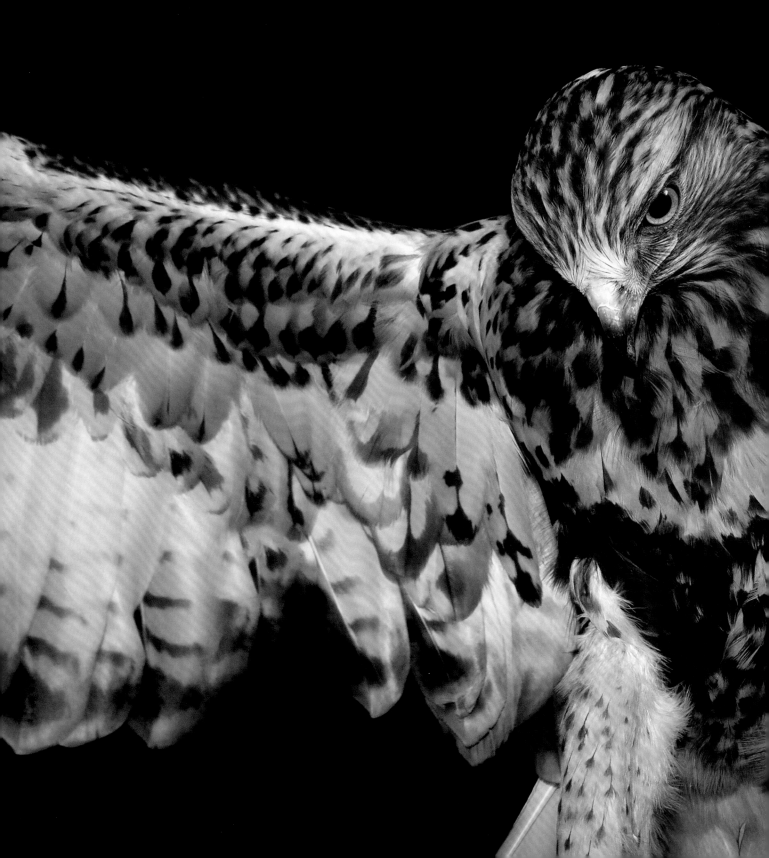

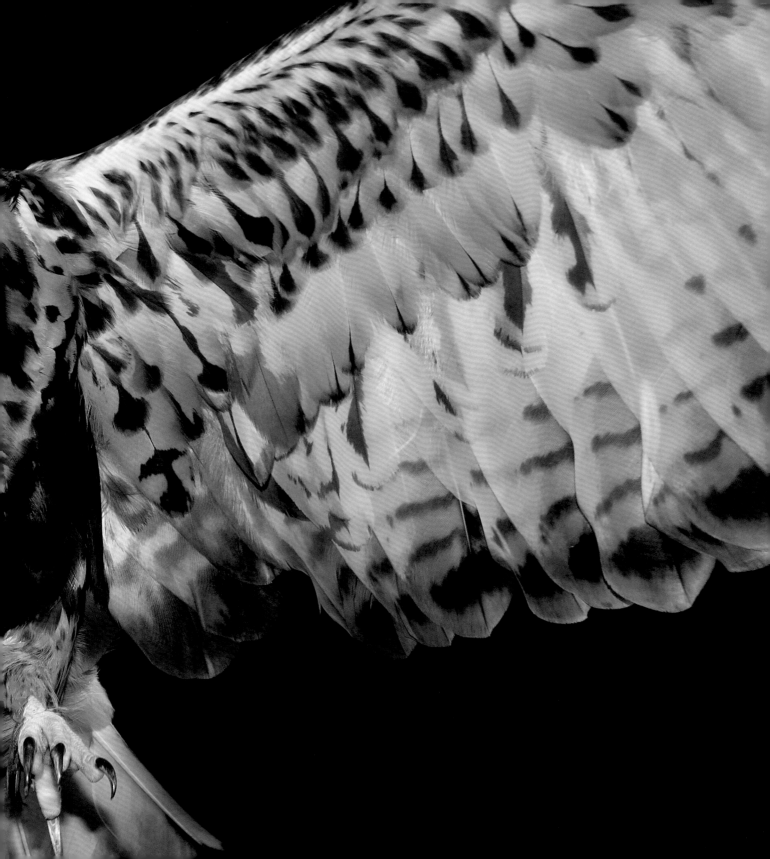

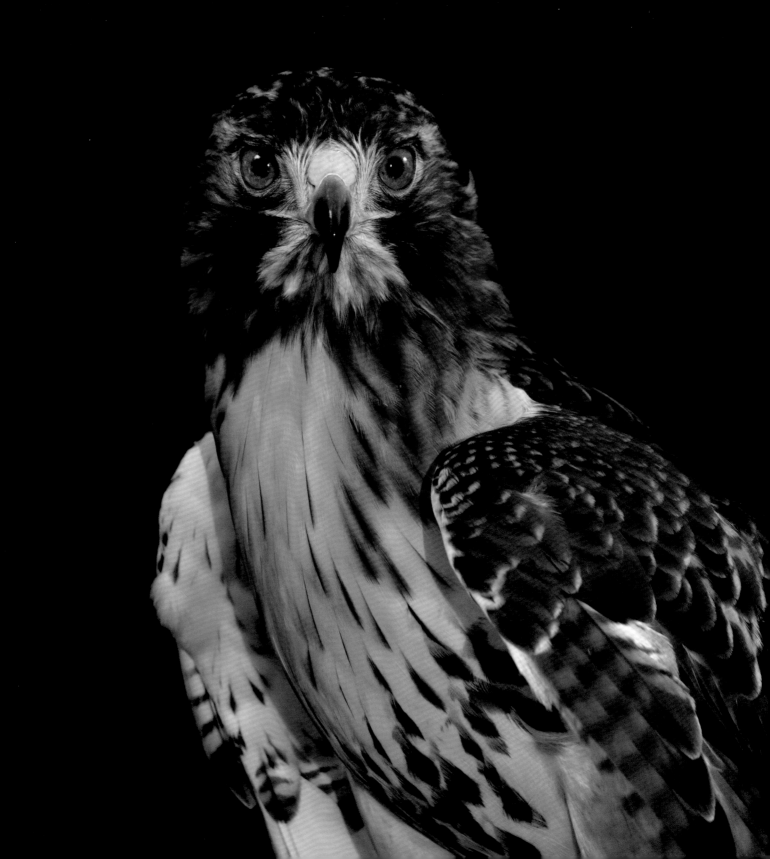

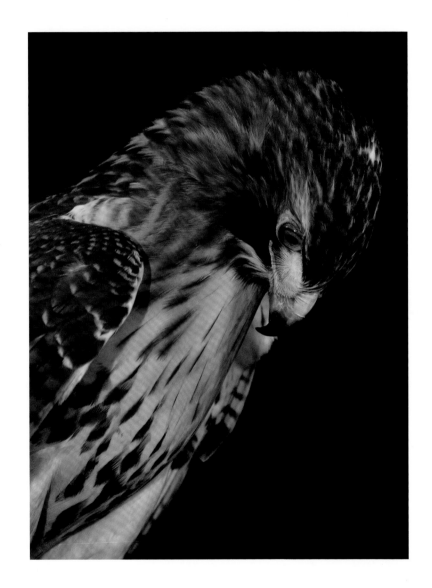

GREAT GRAY OWL

—

This immense owl is really just all fluff. The world's largest owl by length,
the great gray owl can measure up to thirty inches tall, with a wingspan
of up to five feet. However, even the largest great gray owl would only
weigh about four pounds. Nicknamed the "phantom of the north," the great
gray owl can hear prey that is buried underneath up to two feet of snow.
The owl then plunges through the surface of the snow, diving as deep as its
body is long, to get the animal.

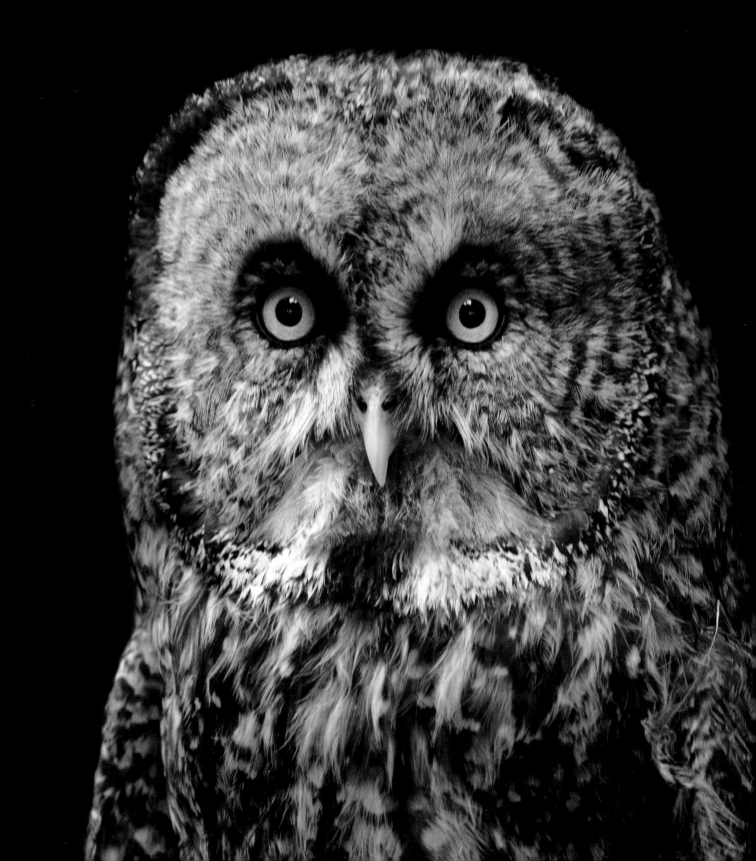

KESTREL

—

Kestrels are renowned raptor aerialists. A kestrel is a type of falcon that is able to hover in midair. This feat is achieved by beating its wings back and forth extremely fast, much like a tiny hummingbird. While hovering or "kiting," kestrels scan the ground for insects, lizards, mice, and other small animals to eat. Once they spot their prey, they dive down and scoop it up in their talons.

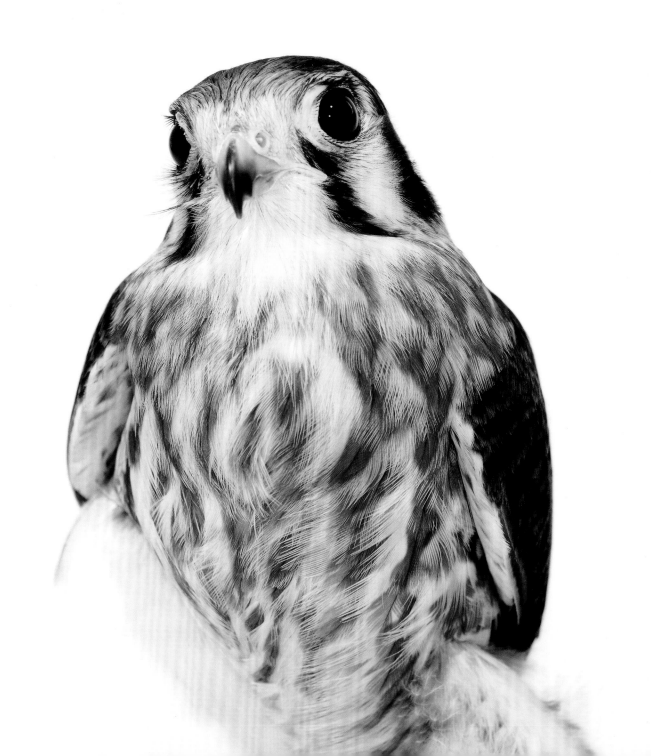

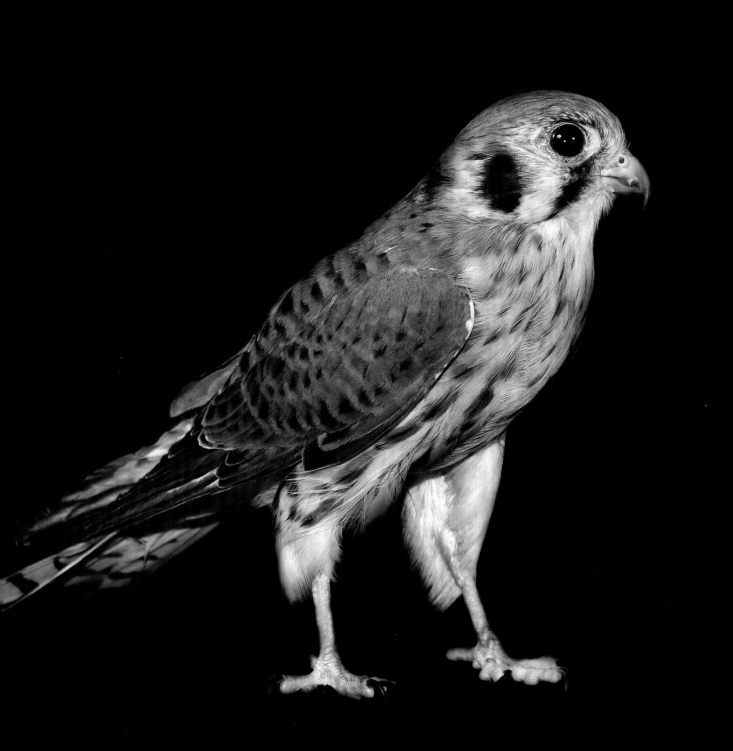

overleaf

LESSER YELLOW-HEADED VULTURE
—

This large vulture can smell a rat—that is, if it's dead and decaying. Unlike most birds, the lesser yellow-headed vulture has a very keen sense of smell and can detect the scent of carrion. King vultures lack this olfactory talent and often follow the lesser yellow-headed vulture to find carcasses. Once there, however, the king vulture takes the lead and uses its superior beak to tear open the food. Through this mutual dependence, both species thrive.

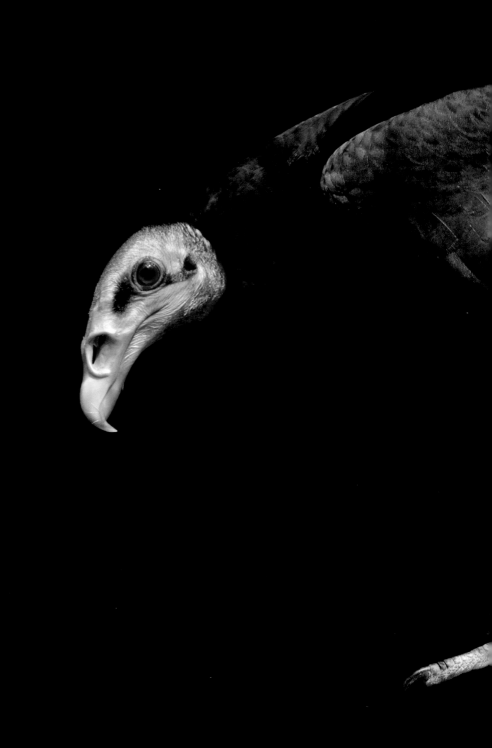

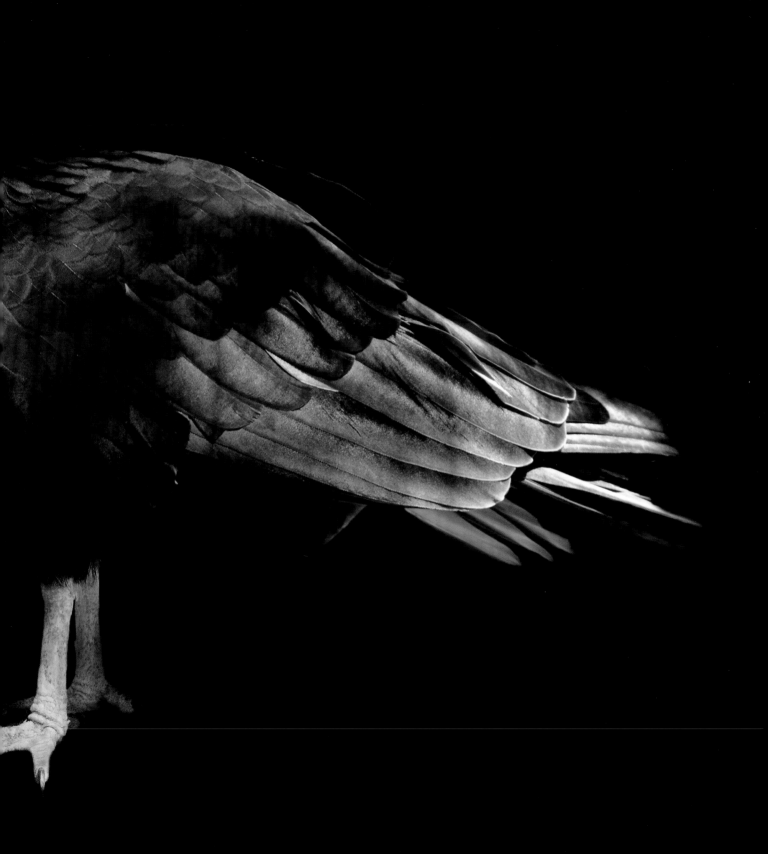

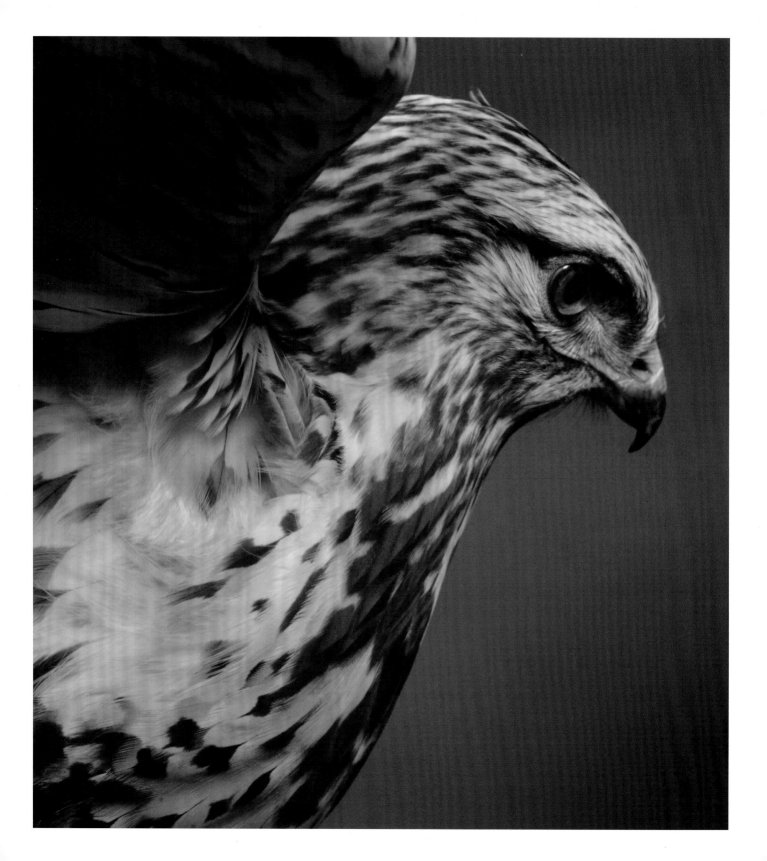

ROUGH-LEGGED HAWK

—

Rough-legged hawks may have x-ray vision—or at least may be able to see UV light. This hawk is remarkably well adapted to hunting voles, which constitute up to 90 percent of its diet seasonally. It has been speculated that rough-legged hawks may be able to actually see a vole's urine or scent markings, which are only visible in the UV range of light, and that this is what makes these birds so adept at finding their prey. These hawks have huge appetites. An adult bird often eats up to a quarter pound of food per day. This is roughly one-tenth of its body mass and would equal five voles. As the name implies, the rough-legged hawk has feathers all the way to its toes, a trait that is shared by only a few other species of hawks.

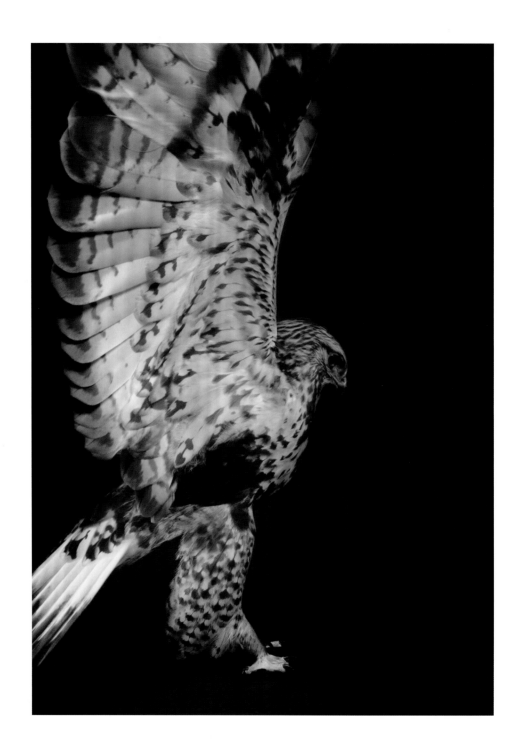

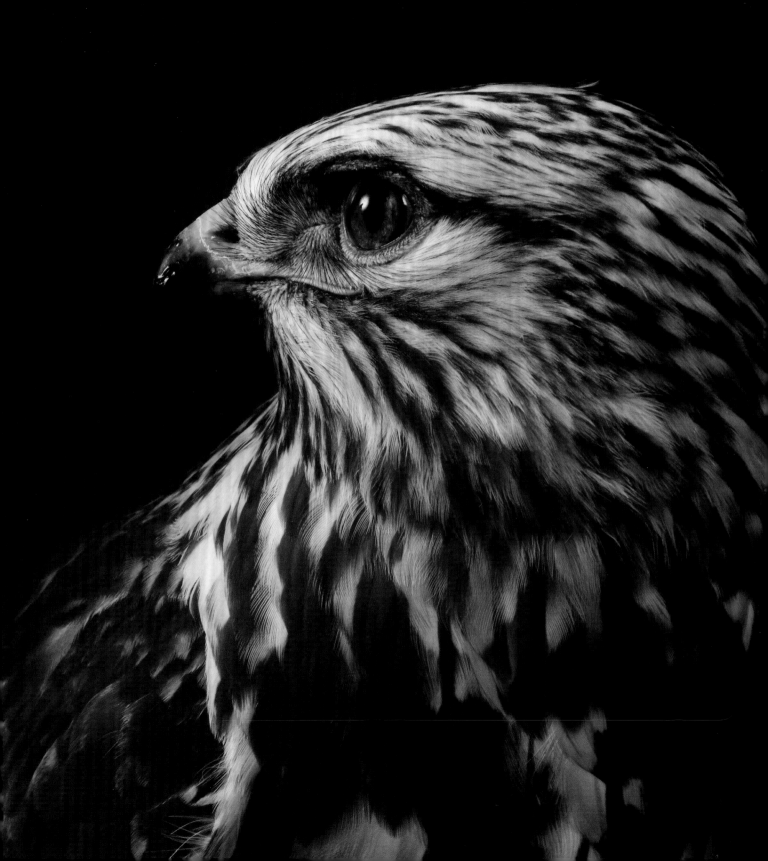

EASTERN SCREECH-OWL

—

These pint-sized raptors have long been the source of big fear. Owls
have traditionally been associated with many myths and superstitions
surrounding death, birth, and the occult; although it's the smallest
owl in North America, the eastern screech-owl is no different. Despite
its name, this strictly nocturnal owl does not screech but instead emits
a spooky trill or whinny, which many people find eerie. Like all owls, the
eastern screech-owl's flight is completely silent, due to serrated flight
feathers that muffle any sound. This allows them to hunt undetected. The
screech-owl chick on page 100 was four weeks old when photographed.
Chicks rely on their parents for food until they are several months old.

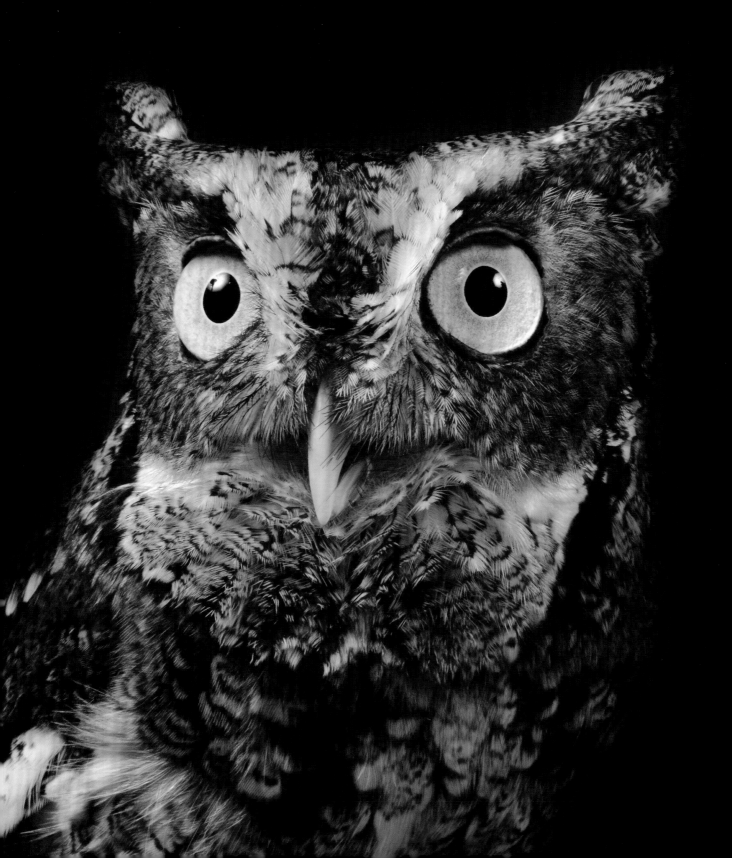

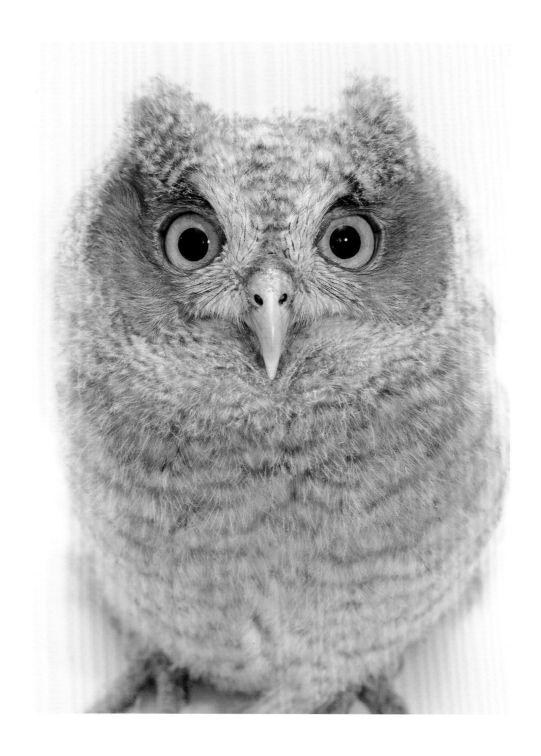

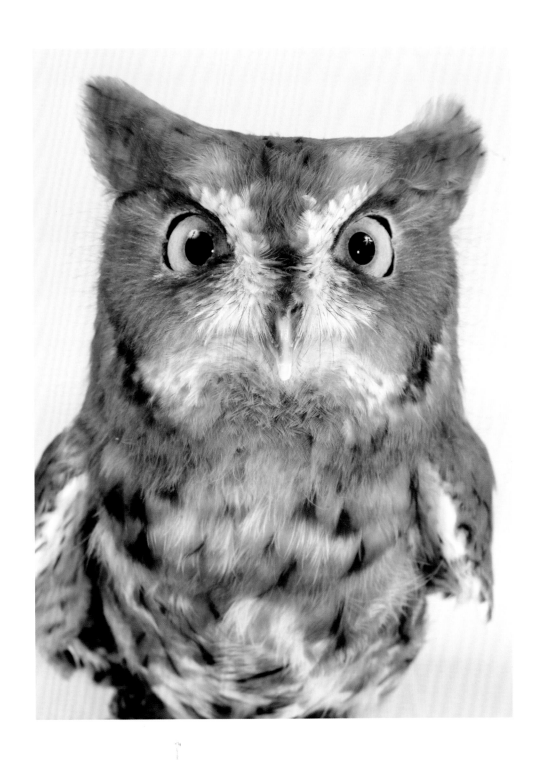

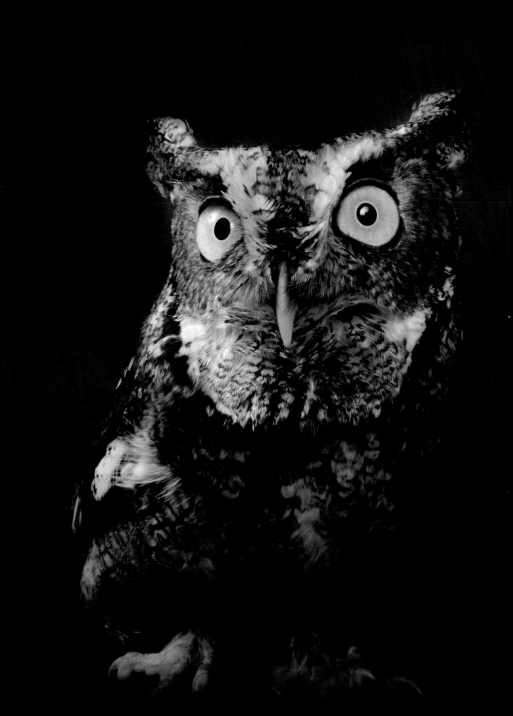

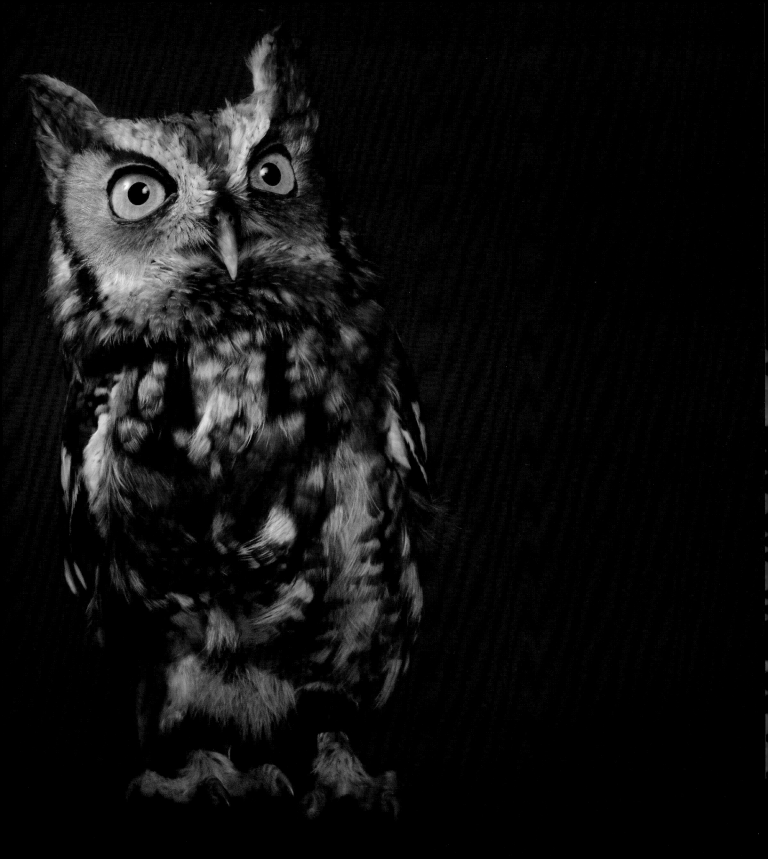

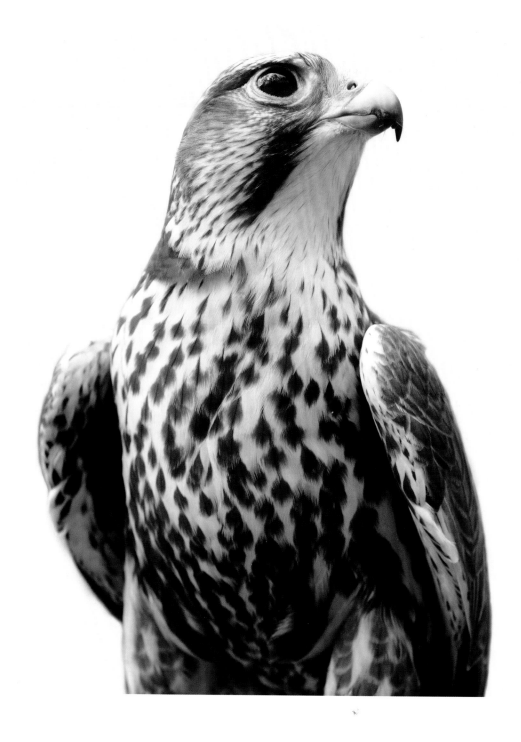

SAKER FALCON

—

The saker falcon does not have an inside voice. These relatives of peregrine falcons often emit bold, screeching calls while performing aerial dives to attract mates. Successful breeding is all-important for these raptors; saker falcon populations are currently in rapid decline, and the once prevalent raptor is now listed as an endangered species. The biggest threat to the survival of the saker falcon is the illegal trapping of young females for the falconry trade in parts of the Middle East. Female birds are often preferred for falconry because they are larger than the males, and young birds are believed to be more easily trained; however, the removal of vast numbers of females has drastically reduced the breeding potential of the wild population.

SHORT-EARED OWL
—

This medium-sized owl loves a good luau. The short-eared owl is the only owl native to the Hawaiian Islands and lives on all of the major islands there. It is also one of the most widely distributed owls in the world and can be found on all continents except Antarctica and Australia. The short-eared owl is one of the only species of owl that actually builds its own nest. Whereas most owls recycle the nesting spots of other birds, the short-eared owl builds one from scratch—literally—by scratching and scraping a bowl out of the earth and lining it with soft grasses and downy feathers.

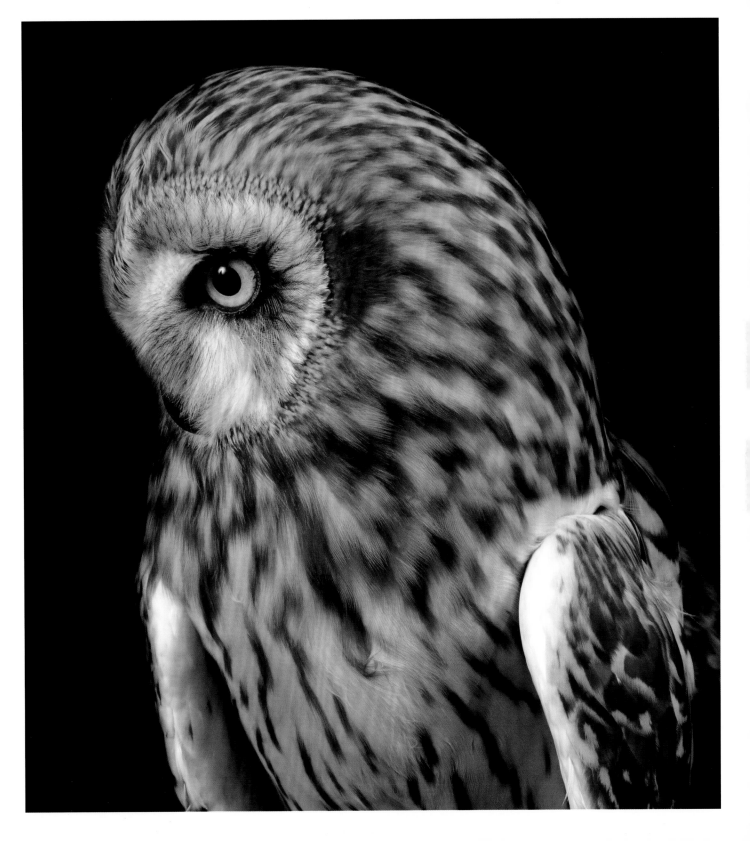

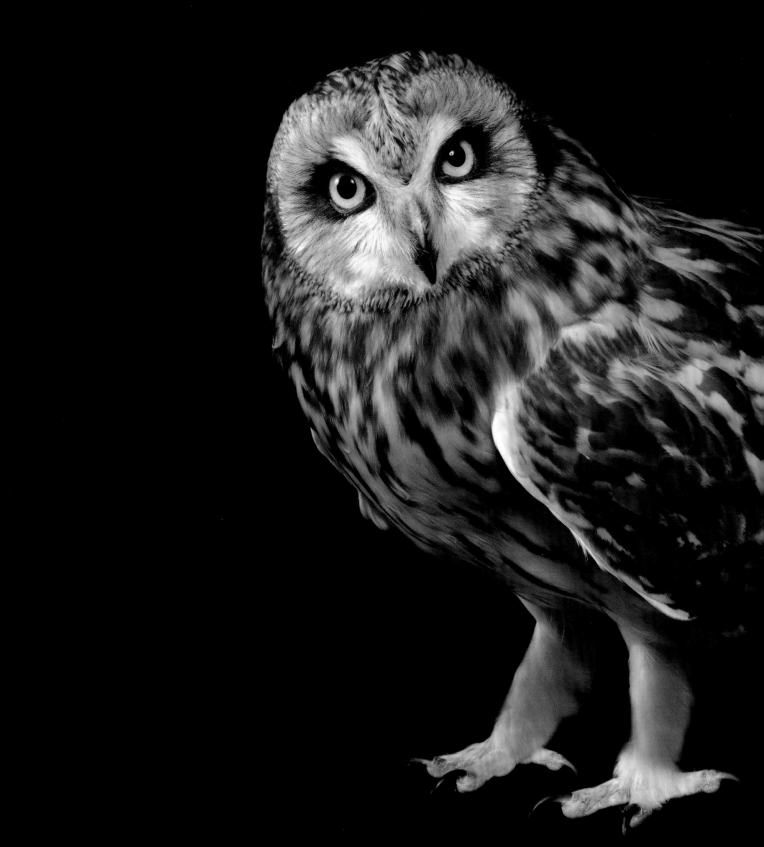

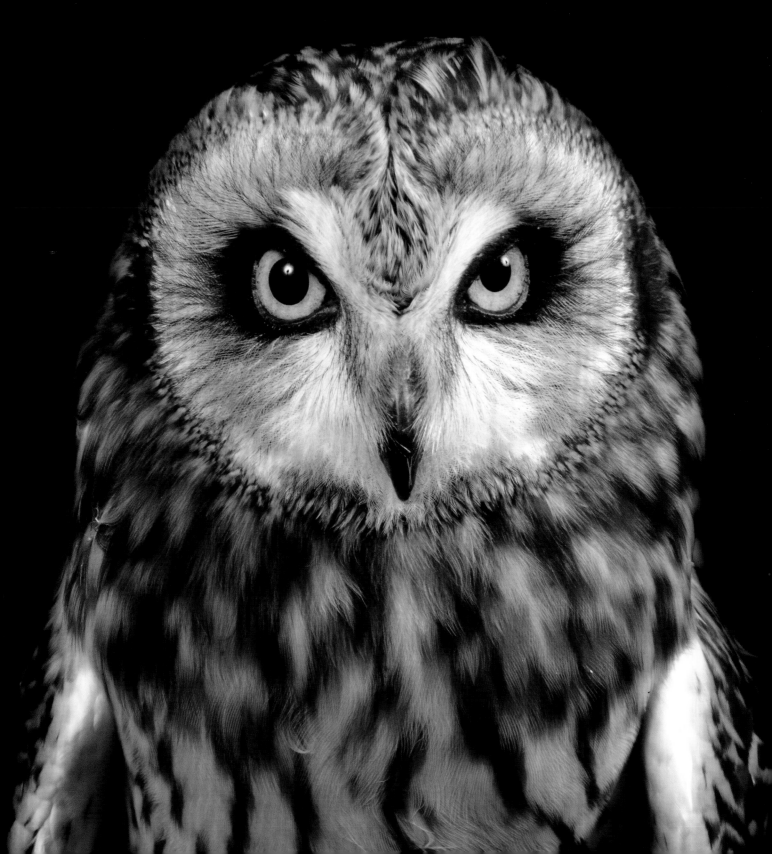

SNOWY OWL

—

The striking snowy owl has been a mysterious muse for millennia.
Depicted in European cave paintings dating from more than thirty
thousand years ago, these rarely sighted, ghostlike owls continue to inspire
artists and birders today. Unlike most other owls, snowy owls are diurnal
and hunt predominantly in the daytime. Snowy owls live and nest in
the Arctic but migrate to parts of Canada and the northern United States
for a brief stay during the winter months.

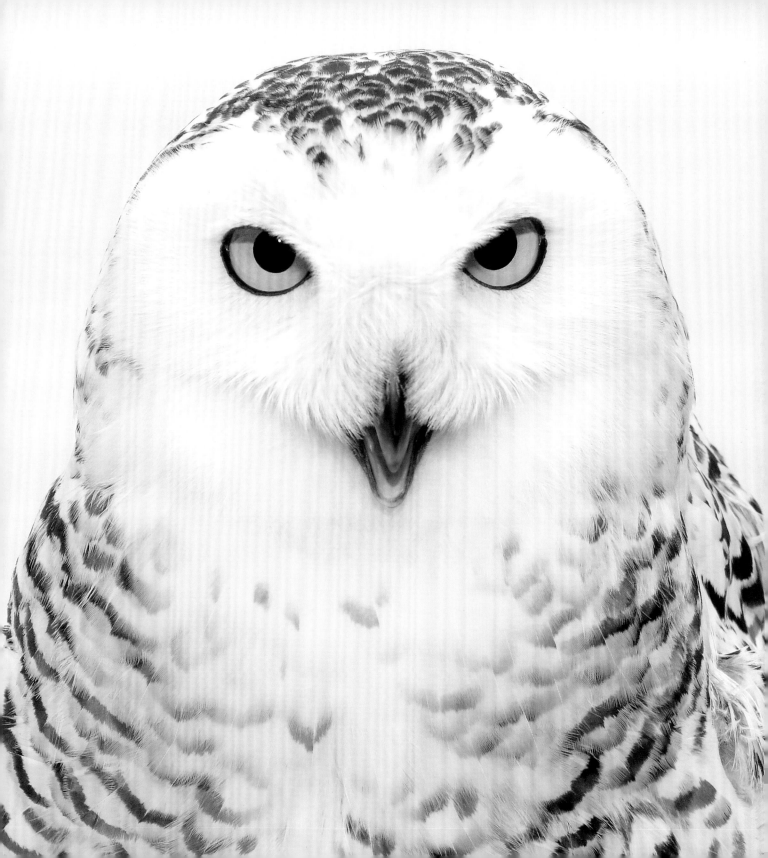

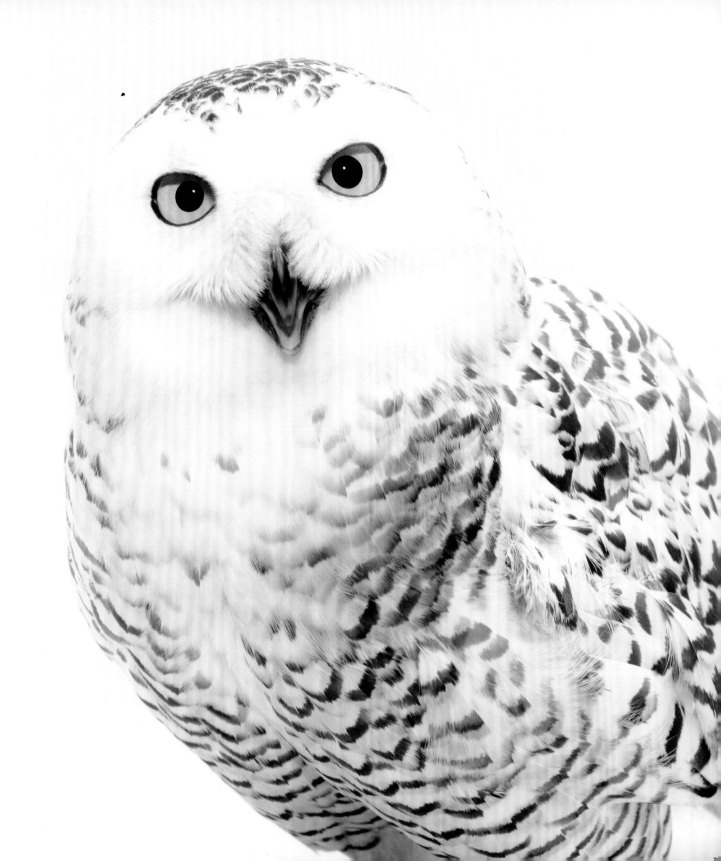

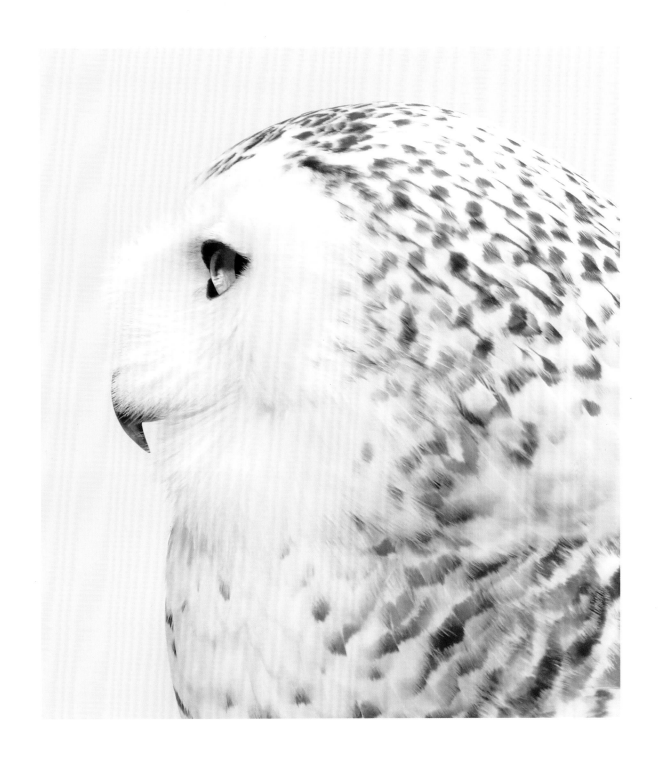

TURKEY VULTURE

—

Turkey vultures are nature's janitors. Turkey vultures do not kill prey but instead scavenge on animals that are already dead. In this way, they provide a valuable service to the ecosystem by cleaning up our forests, grasslands, and deserts. A turkey vulture's enormous wings can span up to six and a half feet and can carry them up to two hundred miles in one day in search of food.

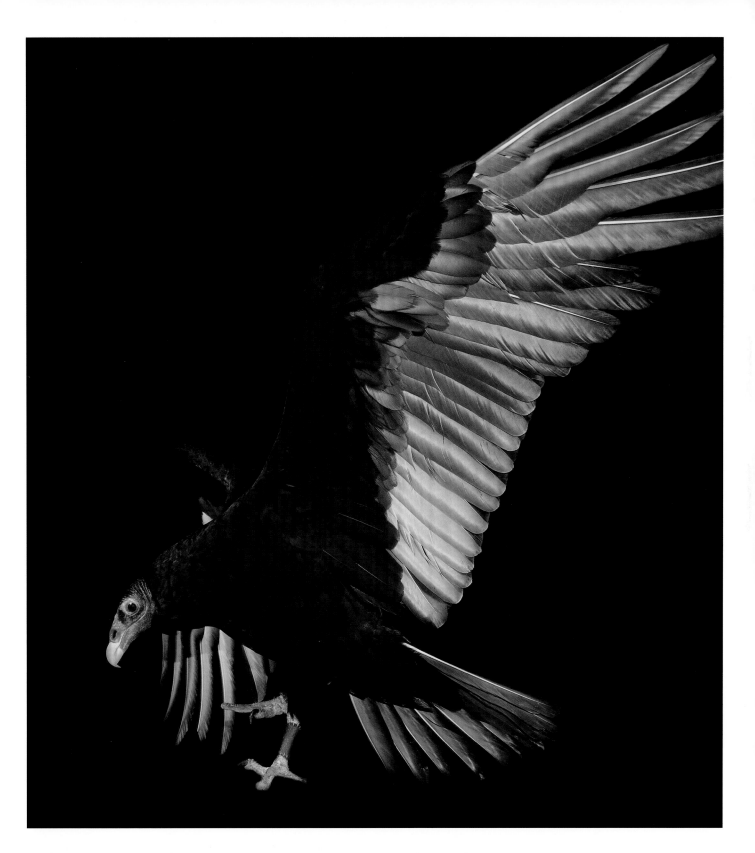

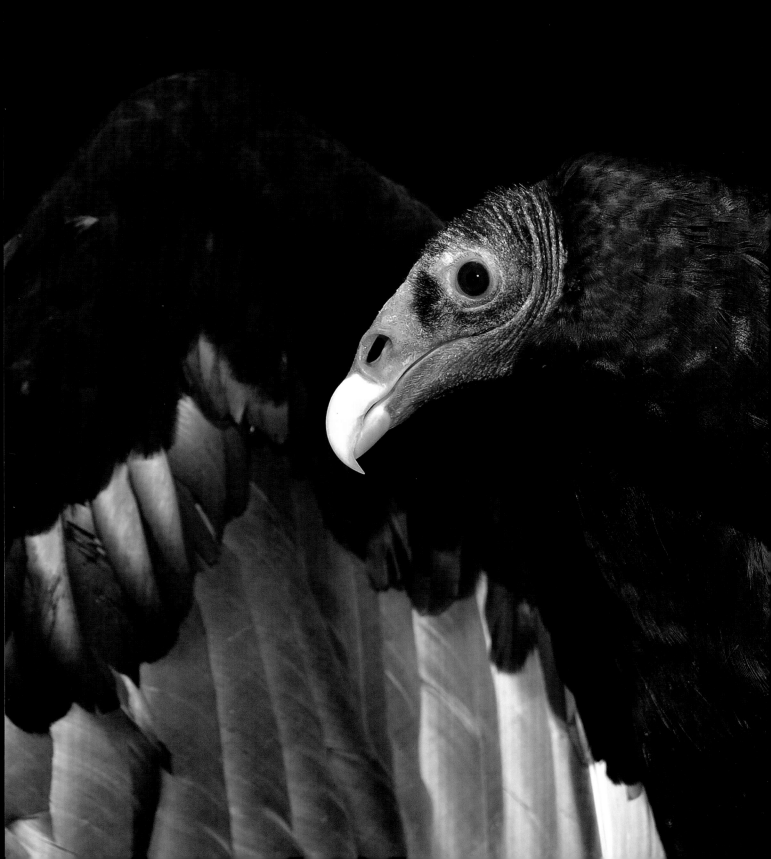

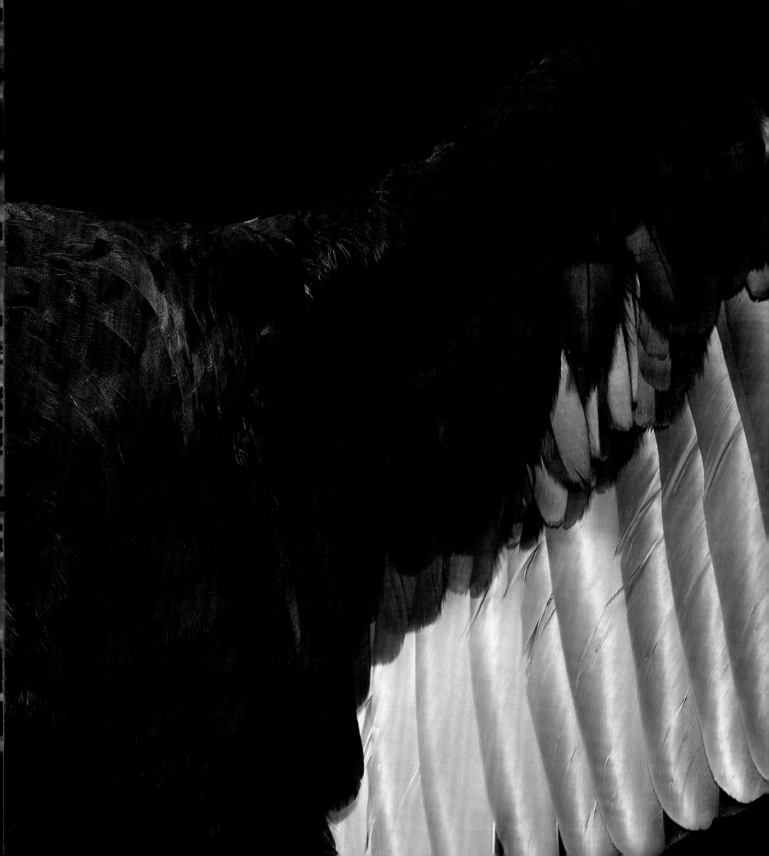

SPECTACLED OWL

—

Spectacled owls are moon worshippers. Like most owls, they are nocturnal;
they tend to be most vocal on bright, moonlit nights. These solitary owls,
named for the white markings around their eyes, come together only briefly
to breed and then return to their solo lives. Although they are not considered
endangered, the spectacled owl faces the challenges of rapid habitat loss,
like many animals found primarily in tropical rain forests.

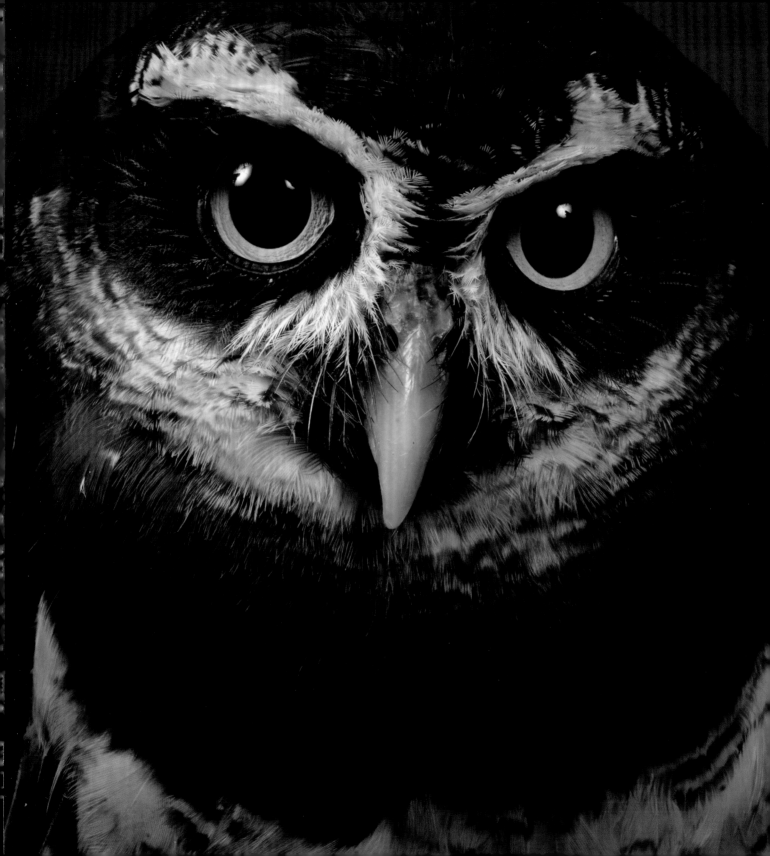

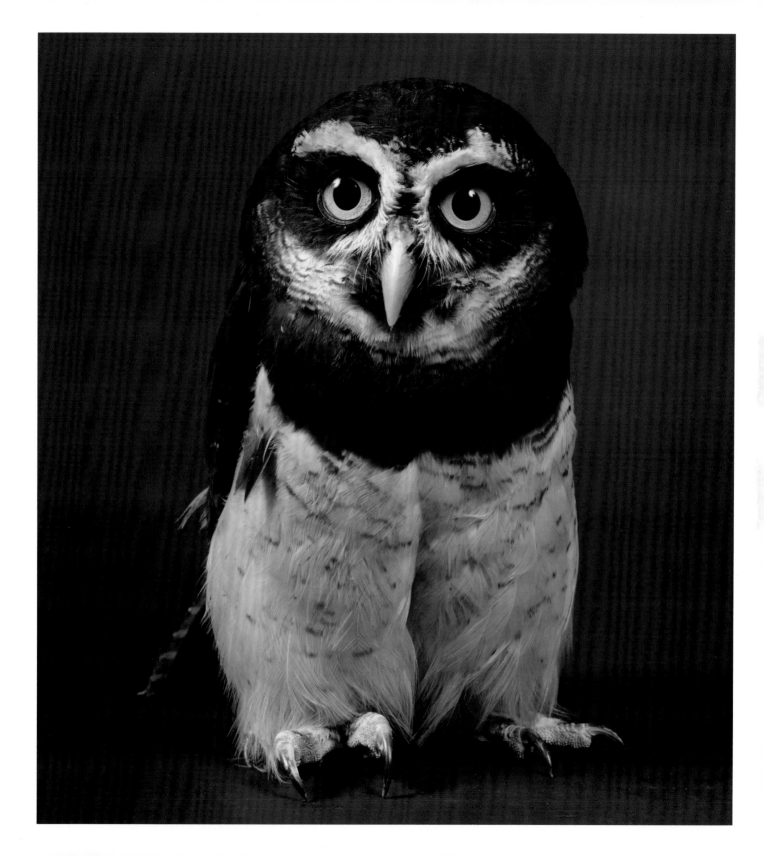

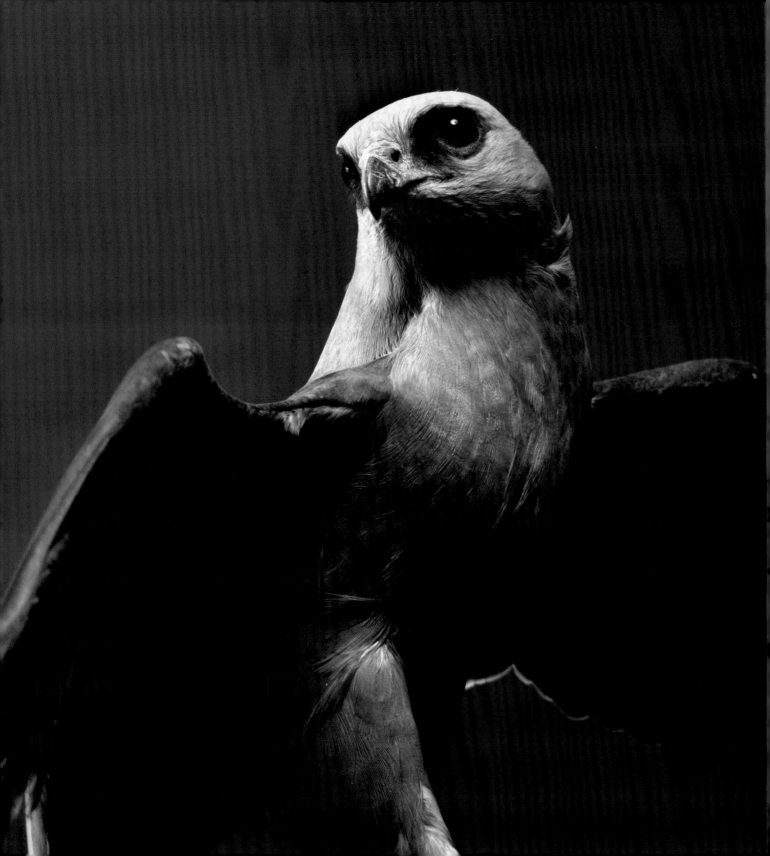

MISSISSIPPI KITE

—

Mississippi kites don't tell their neighbors to buzz off. The nests of these small, clever raptors are often found very near wasps' nests. The proximity of these prickly neighbors is thought to dissuade climbing predators such as raccoons from eating the kites' eggs or chicks. The kite is a very agile, acrobatic flyer and spends much of its time in the air. Mississippi kites primarily eat large insects such as grasshoppers, cicadas, and other crop-damaging insects, which they catch "on the wing."

Acknowledgments

It takes so many people to make a book, and without even one of them, the whole
effort fails. Thank you to the wonderful team at Princeton Architectural Press
for another beautiful collaboration and to Kevin and Jennifer Lippert for giving me
a home in the publishing world. To my editor, Sara Stemen: I feel so lucky to be able
to continue to work with you; thank you for sorting out my words and thoughts!
Special thanks to Mia Johnson for the stunning design that brought this work to life.

Thank you to my agent, Joan Brookbank, through whom all things are possible.
I am so grateful for your guidance, grace, and friendship.

To my family: I love you.

Finally, to all of the caretakers who gave me access to your beautiful birds, thank you:
Natalie Childers, Michelle Houck, and the staff at Carolina Raptor Center
Mary-Beth Kaeser and the dedicated volunteers at Horizon Wings
Vermont Institute of Natural Science
Vivian Maxson and Born to Be Wild Nature Center
Arianna Mouradjian and Wildlife Rehabilitators Association of Rhode Island